D0854564

NB 6364233 6

Landscapes in Watercolour

NORTH EASTERN LIBRARY SERVICE
AREA LIBRARY, DEMESNE AVENUE
BALLYMENA, Co. ANTRIM BT43 7BG
NUMBER 6364233×
CLASS 751.422436

Landscapes in Watercolour

Robin Capon

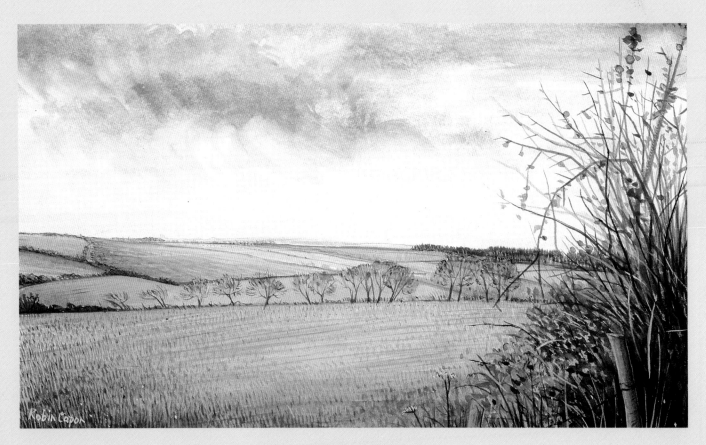

B. T. Batsford Ltd, London

ACKNOWLEDGEMENTS

I should like to thank the following for permission to reproduce photographs and illustrations:

Blackburn Museum and Art Gallery, pp 52 (71), 97 (118), 98 (119), 101 (122), 102 (123); The British Council, pp 23 (22), 34 (51); The Burton Art Gallery, Bideford, pp 64 (83), 72 (90); Rachel Capon, pp 46–7 (63 and 64); Leeds City Art Galleries, p 8 (3); The Tate Gallery, London, p 8 (2); The Victoria and Albert Museum, London, p 9 (4); Williamson Art Gallery and Museum, Metropolitan Borough of Wirral, pp 53 (72), 82 (105), 95 (116), 96 (117), 99 (120), 100 (121).

Also, many thanks to Rosalind Dace for her editorial work and to my wife, Tricia, for her usual enthusiasm and help, and her agility on the word processor!

Except where otherwise stated, all the illustrations are by the author.

Robin Capon
Woolfardisworthy, North Devon, 1992

(Previous page) *View towards Melbury Forest.* Watercolour and gouache.

© Robin Capon 1992
First published 1992

All rights reserved. No part of this publication may be reproduced, in any form or by any means, without permission from the publishers.

Typeset by Goodfellow & Egan
Printed in Hong Kong

Published by B T Batsford Ltd
4 Fitzhardinge Street London W1H 0AH

A catalogue record for this book is available from the British Library

ISBN 07134 6877 7

Contents

No man ever painted, or ever will paint, well, anything but what he has early and long seen, early and long felt, and early and long loved.

John Ruskin

Introduction

LIKE ME, perhaps your first experiments with watercolour paints were at school. We were each given a small, black tin box which, when opened, revealed a very limited range of often dirty colours and a short, well-used brush. The lid of the box doubled up as a mixing palette and, with the additional luxuries of a jar of water and a sheet of quarter-imperial paper pinned to a board, we were deemed well set up to paint a masterpiece. Such an introduction was bound to test the ingenuity and capabilities of even the most able student, with the rest probably vowing never to open a paintbox, especially a black one, again!

I survived the schoolboy initiation into watercolour and came to regard it as a technique particularly suitable for conveying my love of landscape. By their very nature, watercolour processes, like the wet-in-wet method, involve a degree of chance. However, watercolour is also a very sensitive medium. Concerned with light and dark, and often using translucent colour, it is the painting medium which, possibly more than any other, is able to capture atmosphere and mood with nuances of feeling and expression. Landscape is a subject which is unrivalled in its immense variety and changeable moods, and watercolour is the ideal medium for interpreting these.

Initially, we all find the prospect of putting brush to paper a rather daunting one. In a landscape painting there are many problems which have to be tackled, some simultaneously. We are often trying to deal with technical factors, such as the mixing and application of paint, while at the same time observing and interpreting the subject matter. We need to be constantly thinking about composition, the interplay of colours and shapes, of light and dark, detail and texture, and so on. But such problems become an integral part of our fascination with watercolour. Undaunted and full of enthusiasm, we are ready to meet any challenge!

I am certain that everyone has some form of creative ability. The ability to draw is a fundamental asset to the watercolourist, just as it is to any artist, but many people also discover an instinctive flair for working directly with colour and form. Painting, like drawing, is a continuous, developing activity, so if you stop for any length of time you will get out of touch. Like any other artistic pursuit, success is not founded totally on ability; more important are enthusiasm and a willingness to try out ideas and techniques, to practise, experiment and, above all, persevere!

I am lucky to be able to devote a large amount of my time to painting, but many enthusiasts have limited hours available. They may be absolute beginners, or be coming back to the medium after a long absence, and these are factors I have particularly borne in mind whilst compiling this book. Whether you are a 'rusty' enthusiast, an absolute beginner or a more accomplished painter wishing to develop your work, the topics covered in these pages will help you establish a confident basis from which to progress in your own individual way.

The great English landscape artists of the eighteenth and nineteenth centuries were the first to explore the potential of watercolour. In the traditional English watercolour, thin, transparent washes of colour rely on the white of the paper for their effect. The highlights are achieved by leaving patches of white paper, and successive washes are applied to create tone and areas of deeper colour. In areas of thin wash, transparency and luminosity are enhanced by the underlying white paper; overlaid washes produce stronger tones because more light is absorbed and less reflected from the paper. The paint itself consists of pigment ground up with water-soluble gum arabic; moistened with water, this gives a thin, transparent stain.

Adding black and white to the colour range or combining watercolours with gouache to form body colour (opaque colour) are variants which will no

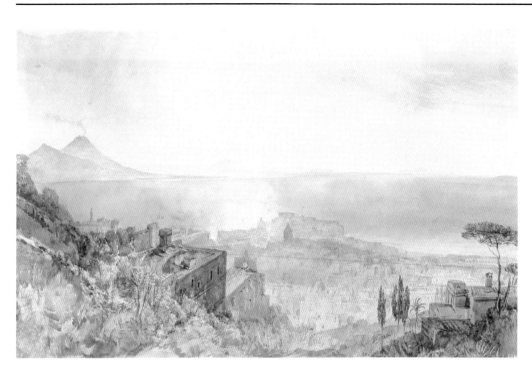

2 (left) *Naples* by J. M. W. Turner. Watercolour. (The Turner Collection, Tate Gallery, London)

3 (below) *Ploughed Field* by John Sell Cotman. Watercolour. (Leeds City Art Galleries)

4 (right) *In a Shoreham Garden* by Samuel Palmer. Watercolour and gouache. (Courtesy of the Board of Trustees of the Victoria and Albert Museum, London)

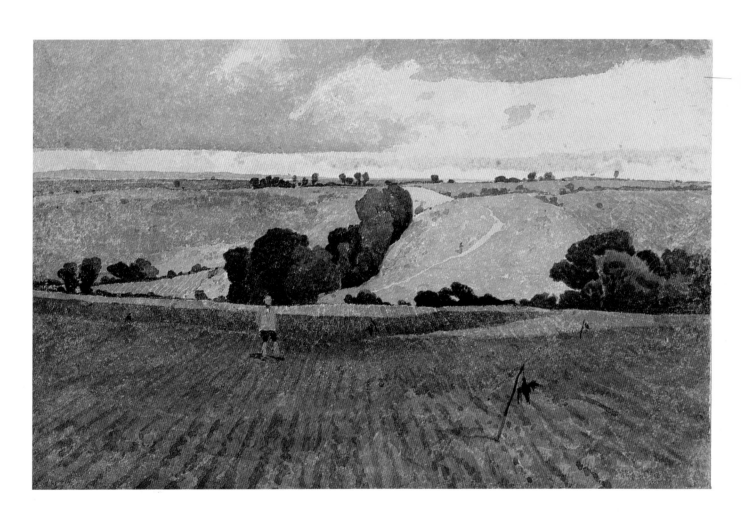

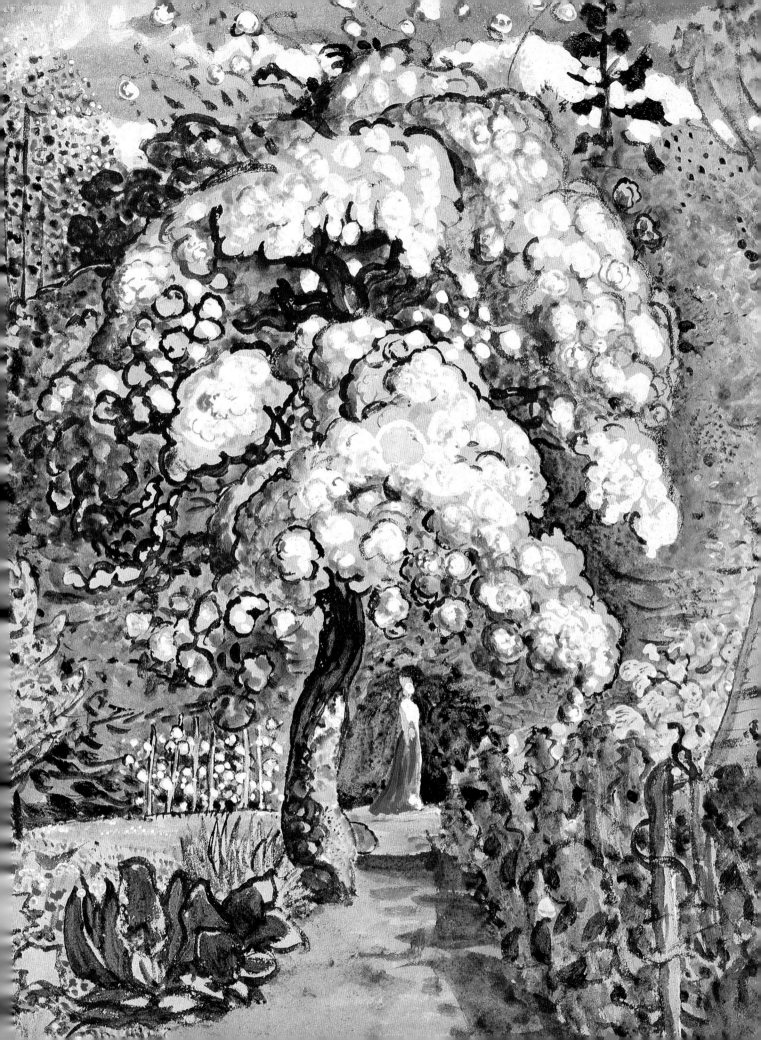

doubt provoke the wrath of the purist. The essence of traditional watercolour is the transparency of colour, with dark shades being made by intermixing pure colour or applying a succession of washes. While respecting the purist approach, one can also accept that watercolour is versatile, to be used in a variety of ways and as the basis for mixed media work. For the beginner, as well as others studying the medium, its adaptability is something which will need to be appreciated and possibly exploited. For this reason, I have included a wide range of techniques (see Chapter 2).

In fact, many notable watercolourists, amongst them Turner, Girtin, Cozens, Cotman and Palmer, used techniques which varied from the accepted norm. See, for example, the use of body colour in Samuel Palmer's *In a Shoreham Garden* (Figure 4). The way an artist uses paint is an entirely personal matter and something which will evolve over a period of time, according to his manner of working and how he wishes to convey his ideas. There are no hard and fast rules in painting. Like Charles Ginner (Figure 51, page 34), you may find that you want to combine ink and watercolour to convey a particular idea, and why not? You may find other techniques with which you have some sort of affinity and which you can use with impact. Don't be afraid to experiment and to discover fresh ways of working. Experience will help you decide what is best for you.

What of the subject matter? There is plenty of exciting material to choose from. As with techniques, if you have the opportunity experiment with as much variety as you can. With experience, you may find that some types of landscape appeal to you more than others and you can concentrate on those. Keep your work lively and interesting by looking for an individual slant on how you present the image – an unusual viewpoint or a different technique. The many examples in this book will give an indication of the exciting scope of landscape painting.

Inspiration and help can also come from looking at the work of other artists. If you can, take time to study the history of landscape painting in watercolours, especially the painters of the late eighteenth century and early nineteenth century. Look at the glorious examples in Figures 2, 3 and 4, painted by three of the greatest watercolourists of that period. Notice the tremendous sense of space and atmosphere in the painting by Turner (Figure 2), how light contrasts with shade and foreground detail complements distant generalizations. In later works, Turner was a great innovator. He used body colour freely, worked into partially dry colour with rags and sponges, and scratched the surface of the paper with a knife to get extra lights. The Cotman painting (Figure 3) demonstrates the value of good composition and design. Notice how a point of reference, such as a figure, can create a contrast in scale and add interest to the general landscape. Much can be learnt by studying pictures in this way. Analyse the other examples in this book by famous artists, and see also pages 52–53, Further Reading and Useful Addresses.

My philosophy in this book is to promote self-discovery. My aim is to present the reader with a good deal of information and visual stimulation, to encourage him or her to try out a wide range of ideas and techniques. By confronting variety in practical exercises and processes, you will find out what works best for you. Equally, you will learn from your mistakes and successes, just as you learn from those of other people. I am not a purist or an evangelist of one particular technique. Be willing to experiment and the following pages will give you a good introduction to landscapes in watercolour. Open the little black box and see what magic you can conjure up!

Choosing Your Equipment

• Paints • Brushes •
• Paper • Other equipment •

1

Choosing Your Equipment

YOU WILL PROBABLY be surprised to discover just how little equipment is actually necessary to paint a landscape. Quite a few of the paintings illustrated in this book have been done using a very limited palette (colour range) and just one or two brushes. Look, for example, at Figure 35 (page 27) for which I used only cobalt, raw sienna and Hooker's green applied with a no. 4 and a no. 0 sable brush.

People taking up watercolour painting often feel that they have to rush out and buy a lot of materials and equipment. This is not so. Keep your equipment to the minimum, for two good reasons: you will find it less confusing (and less expensive!) and a restricted approach, especially in colour range, generally proves more successful. Start with the basic materials and equipment recommended in the next few pages. As you do more painting, you can add other items when you require them. Find a reputable specialist art shop, which will let you handle and test materials, as well as offering sound advice. Always buy good-quality equipment and take the trouble to look after it.

PAINTS

Two kinds of paints are available: pan and tube (Figure 5). Square or oblong pan colours are found in boxes of watercolour paints. The range of colours varies according to the size of the box, and with some manufacturers it is possible to buy separate pans so that you can select your own palette. Although a small box of watercolours is ideal for location studies, pan colours have distinct disadvantages for studio work. The colours are inevitably solid, and mixing washes will therefore cause greater wear and tear on brushes. Creating mixes may dirty the colours in the box, resulting in 'muddy' colours. If you do a lot of work with pan colours, make sure that the paints are kept pure by wiping them with a clean sponge. Keep a

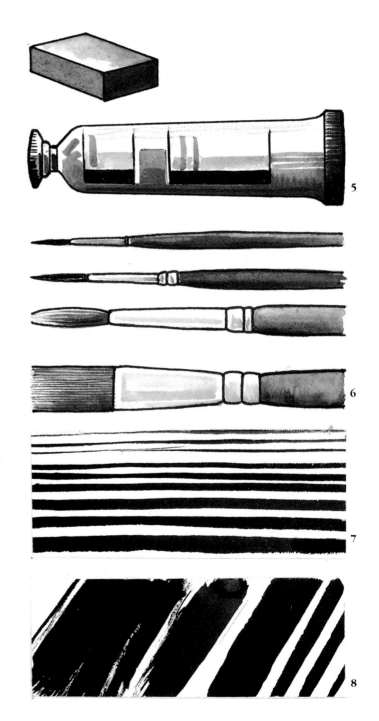

damp cloth in the box so that the paints stay moist and are consequently easier to mix.

Tube paints contain more glycerine and are therefore more soluble. The advantages of tube colours are that they are easier to mix, especially for large washes; they are less likely to produce soiled colours; they are easier on brushes because little scrubbing motion is required to pick up the colour; and, of course, you can buy individual tubes of colour as you need them. The disadvantage of tubes is that there is always a temptation to squeeze out too much, but dried paint can often be wetted and re-used. See page 21 for information on selecting a colour range, and mixing and applying paint.

BRUSHES

Nylon, or similar synthetic brushes, are acceptable as large flats or as one-stroke brushes for general washes of colour, but are unsuitable in smaller sizes. A good watercolour brush has the capacity to hold paint and release as much or as little as you want. The hair of the

brush needs to be fine yet resilient, tapering to a sharp point so that details are possible, even with a large brush. The best brushes are round red sable. These traditionally have black handles and are made from the tail hair of the Siberian Kolinsky mink. Providing they are looked after, quality brushes will prove a good investment, not only economically but also because of the type of work which is possible.

You will see from Figure 6 that you do not need a vast array of brushes. To start with, keep to just four round brushes, sizes 2, 5, 8 and 12. Supplement these with a 2.5 cm flat wash brush and a round no. 6 hog brush, for loosening areas which need to be wetted off. As your work develops, you may discover the need for a wider range – flats, chisel-edged or fan brushes for dry brushwork, a hake for large areas of wash and a rigger for details.

Get to know the capabilities of each brush by testing it out in the way shown in Figures 7 and 8. See how the pressure you apply to the brush and the way you hold it affects the type of lines and strokes it will make. Try a monochrome painting like the one in Figure 9, using a single brush and experimenting with various effects.

9

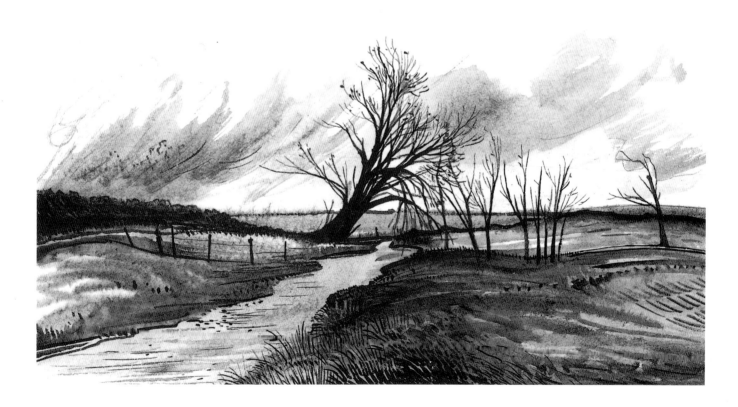

PAPER

The choice of paper can have a significant effect on the final painting as it will undoubtedly influence the degree of success with different painting techniques. The range of papers and their uses can be bewildering to the beginner.

Start with a standard 140 lb (300 gsm) watercolour paper manufactured by one of the well-known suppliers (see pages 109/110). After gaining experience and confidence with this, and depending on the sort of subjects and effects you want to produce, you can adjust the type of paper accordingly.

The surface of the paper is known as the *ground* or *tooth*, and this will vary from smooth cartridge paper to the very rough watercolour types. Paper is said to have a 'right' and a 'wrong' side, the back of the paper being the side which has picked up the even, mechanical texture from the screen on which it has dried. *Laid* papers have horizontal and vertical patterns of lines, created by the wire mesh of the mould, and *wove* papers, lifted from a different mesh, have an overall texture like canvas. *Not* papers (not hot-pressed) have a coarse or open surface texture, while *hot-pressed* (*HP*) papers have a smooth surface.

Just as the surface of the paper can vary, so can its weight and general characteristics. All watercolour papers are sized during manufacture, otherwise they would be like blotting paper. The amount of size used by different manufacturers affects the way the paper responds to paint. Suppliers now indicate the thickness and quality of the paper by stating its weight in grammes per square metre, though many watercolour papers are still denoted by weight in pounds per ream. Thus, 72 lb (155 gsm) paper will be thin and lightweight, while 300 lb (640 gsm) will be thick and coarse in texture. Most watercolour papers are still sold in the old 'Royal' sizes (24 x 19 in) or 'Imperial' (30 x 32 in) although, like all papers, these are changing to ISO metric sizes; A1 is 596 x 840 mm and A4 is 210 x 298 mm.

Ideally, the best paper is made from 100 per cent rag and is handmade, although I doubt if many of us could afford to paint on this very often! Instead, there are many other fine manufactured papers. Look for some of these watermarked or trade names: Saunders, Arches, Fabriano, Barcham Green, Grumbacher, Canson, Whatman, and Winsor and Newton. In general terms, use a smooth cartridge paper for ink-and-wash

work and delicate brushwork techniques, and a Rough or Not paper for wet-in-wet techniques, dry brush effects and bold, dramatic ideas. For masking fluid techniques choose a smooth paper which has been surface-sized. Also available are pigmented papers, such as the Camber Sand (light tan) and Turner Grey (blue-grey) papers manufactured by Barcham Green (see Useful Addresses).

Because watercolour painting techniques often involve very wet washes of colour, most types of paper will need to be stretched before beginning the work. Very heavy paper, such as 200 lb (425 gsm) or 300 lb (640 gsm) Rough, can simply be pinned or taped to a board with masking tape, but other papers will need stretching in the manner described on page 87.

10

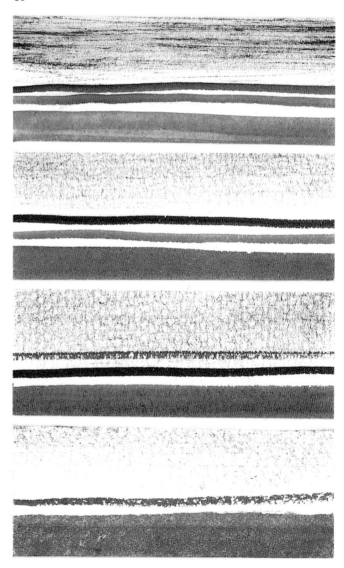

11 *South Downs, near the Chanctonbury Ring.* Watercolour on stretched cartridge paper.

If you have not used a particular paper before or tried to create a certain effect with it, it is always a good idea to experiment first on a small piece. Figure 10 shows how the paper can influence different brushwork effects. Four qualities of paper are shown, ranging from smooth cartridge at the top to rough watercolour paper at the bottom. As I have done here, test the paper with dry brushwork, lines of different colour strength and wash (and maybe also masking fluid), to see how it responds. In Figure 11, stretched cartridge paper was deliberately chosen so that the fine brushwork effects could be achieved.

OTHER EQUIPMENT

That well-known maxim, 'the better the artist, the more limited his palette', can also be related to other equipment. There is absolutely no need to start with a lot of equipment, the best approach being to wait until you need a particular item or are ready to try something different before you invest in it. The beginner is often pressurized by displays in shops and information and advertisements in catalogues, society magazines and periodicals to buy expensive, perhaps specialist, equipment, which he often finds he can manage very well without. Some painters patent or sponsor products, but leave Mr Celebrity's palette and watercolour set to Mr Celebrity – in any case, you don't want to paint like him, you want to paint like you!

Before you can make use of brushes, paints and paper, you need an idea. For the landscape painter this means getting out and about in the landscape, making drawings and colour sketches, and collecting notes and information. To do this successfully, you will need more than just pencil and sketchbook. As in Figure 12, try out charcoal, pastel, a soft-leaded sketching pencil and coloured pencils. The techniques you use to

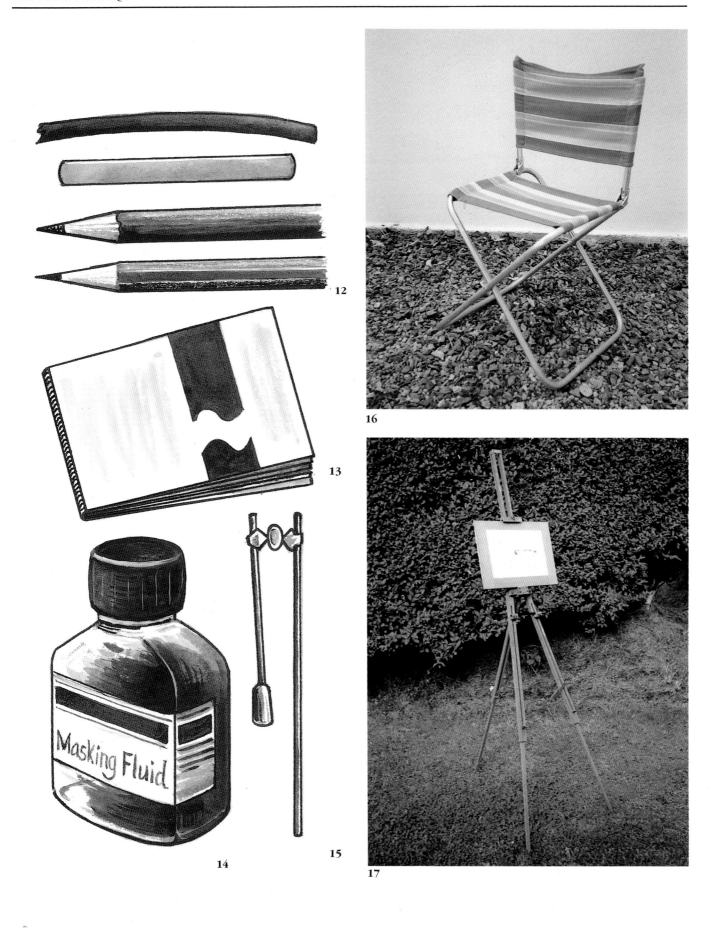

12

13

14

15

16

17

collect research drawings of this type will, of course, relate to the sort of ideas which interest you and the ways that you intend interpreting them. Be prepared to do some work in colour, either using a small box of watercolours or another colour medium such as pastels, crayons or water-soluble pencils. Speed is often essential in such work and you may find you can sketch quickly with a sketch pen, ballpoint pen or fine fibre pen. There are many drawing media from which to choose.

A good-quality A4 cartridge sketchbook is the most versatile as it will suit any medium (Figure 13). Often the best ideas present themselves unexpectedly when you are out on a serious sketching trip, so get into the habit of carrying a pocket sketchbook. Use a watercolour block containing sheets of heavy-quality paper if you intend doing a lot of painting on the spot. If you want to be comfortable, take along a lightweight folding stool (Figure 16) and work at a sketching easel (Figure 17).

For a mixing palette, use an old saucer or china plate. On these, dried mixed colours can easily be revived with water to produce colour as true as when first mixed. Personally, I find plastic or metal palettes unsympathetic to paint, and difficult to mix on.

Other equipment will depend on the sort of techniques you eventually include in your repertoire. You may favour masking out fine detail with masking fluid (Figure 14). This can also be sprayed on with a blow-pipe diffuser (Figure 15) to create a stippled or textured area when overlaid with wash. The diffuser can be used for other spray and texture techniques, as can wax crayon. If, like some artists, you find it interesting to cut back through layers of wash to reveal the white beneath, you will need a sharp knife and some fine glasspaper. These and other techniques are described in Chapter 2; if you find you want to develop them further you can easily obtain the necessary materials and equipment. Add other items to your 'toolbox' as you find them useful – a sponge, tissue paper, cottonwool, blotting paper, and so on.

The landscape artist isn't always out battling against the elements! Many ideas can be 'worked up' in the studio. If you have a room or part of a room that can be adapted, this is ideal. Make the most of any natural light and install good, adjustable artificial lights. It is wonderful to have somewhere where you can leave work and equipment spread out so that you can return to it whenever time permits.

Using Different Techniques and Effects

● Some thoughts on colour ● Using wash ●
● Wash effects ● Wet-in-wet ●
● Developing wet-in-wet ● Dry brush methods ●
● Opaque effects ● Wash with line and tone ●
● Making textures ● Using masking fluid ●
● Mixed-media effects ●

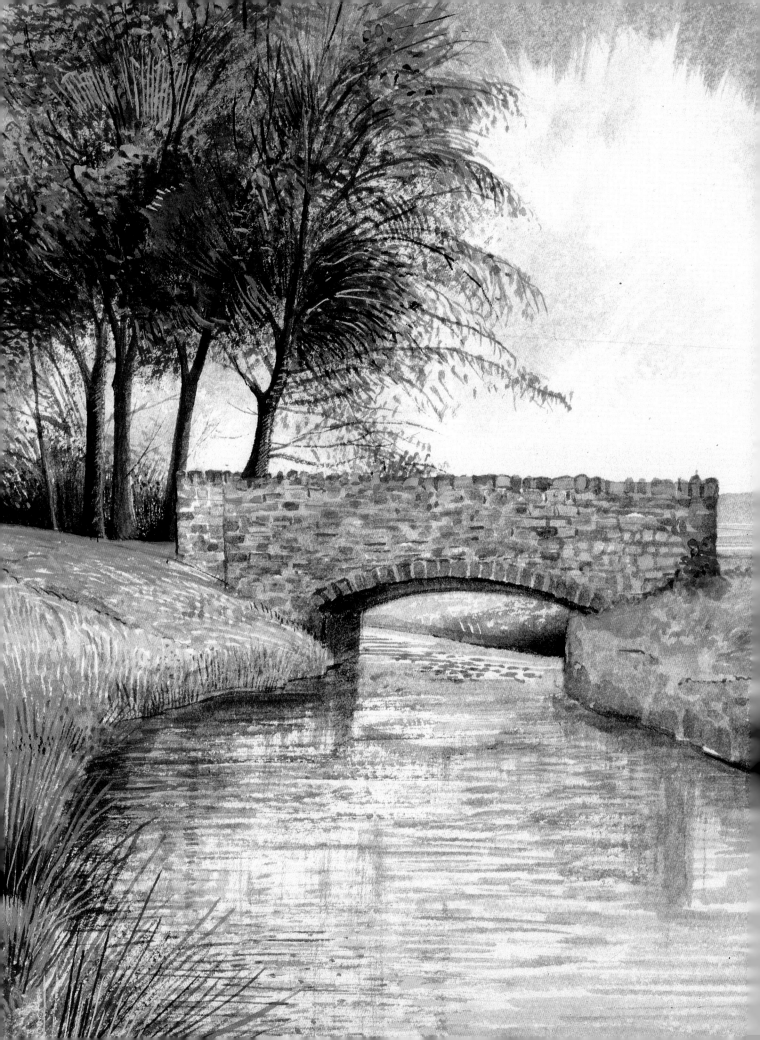

2

Using Different Techniques and Effects

WATERCOLOUR can be used in a variety of ways and will work sympathetically as the basis for a number of mixed media techniques. For the beginner, it is worthwhile exploring the potential of the medium as this will give a sound working knowledge of various applications which may be suitable for landscape painting. Many ideas and effects are described in the following pages which will help you develop this sort of experience. You may well decide to keep to the traditional approach, or you may discover that a combination of techniques is better for the way you want to paint.

SOME THOUGHTS ON COLOUR

The techniques and effects described here are specifically relevant to painting landscapes. Colour is obviously an extensive topic, so if you are keen to know more consult the specialist books recommended in Further Reading.

Remind yourself of the basic colour wheel (below) and paint a similar one for your own reference. This will help you establish a few facts about colour. The colour wheel shows you the three primary colours (red, yellow and blue) and the three secondary colours (orange, green and violet). Each secondary colour is a mixture of the adjacent two primaries. If you want a subtle harmony in your painting, keep to two adjacent colours in the circle. Complementary or contrasting colour is achieved by using colours opposite each other on the wheel. For example, a striking contrast can be made by using a little red in a predominantly green landscape, an effect used by Constable.

Make a few colour tests to experiment with these ideas and then, using a single colour, try an exercise in gradations of tone (Figure 19). Start with very diluted colour for the weakest tone and gradually add more pigment to increase the strength of colour. Progress to a simple, banded landscape, like that in Figure 20, where two colours are used.

Colour is always the most important element in creating the mood of the painting. It can be striking, as in the ink and watercolour effect in Figure 22, or much more subtle, as in Figure 35 (page 27). For landscapes, we generally work with cool colours (greys, blues, greens and soft browns), with the weakest tones in the distance (Figure 21). The foreground may be enlivened with a richer or warmer colour, such as red or purple.

The best way of learning about colour is to experiment with mixing different colours, making a note beside each sample of how it was concocted. Keep this information in your sketchbook where you can readily refer to it.

Use a simple palette or range of colours, and lay them out in a logical order so that you become accustomed to certain colours and where to find them. This will make mixing easier. Start with the following: ultramarine, cobalt, Hooker's green, lemon yellow, yellow ochre, gamboge, raw umber, burnt sienna,

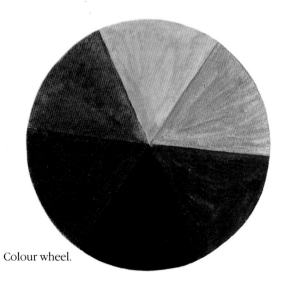

18 Colour wheel.

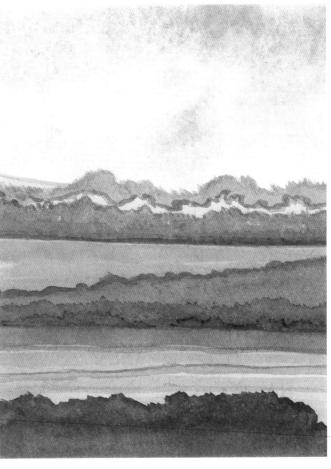

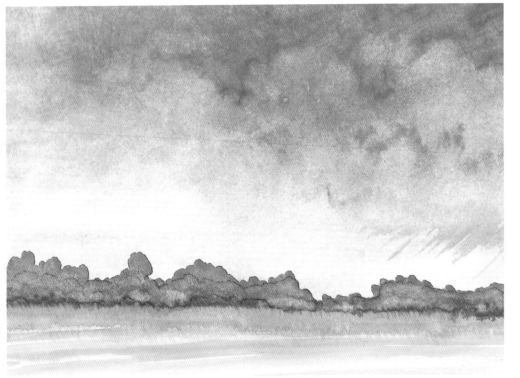

(Above left)
19 Exercise in gradations of tone.

(Above)
20 Exploring different strengths of colour.

(Left)
21 Using colour to suggest depth.

(Opposite)
22 *Back Gardens, Frinton-on-Sea, 1936* by Charles Ginner. Ink and watercolour on paper. (British Council)

burnt umber, alizarin crimson and cadmium red. You may need to adapt this palette as your work develops. You will need to add Payne's grey, black and white and even some gouache colours in order to explore some of the following techniques.

USING WASH

The ability to mix and manipulate thin washes of colour is fundamental to most watercolour techniques. In traditional watercolour, weak washes are applied one over another, working from the palest areas and building up a succession of superimposed washes to achieve stronger, darker tones. Working over or into areas of wash is also the basic approach of various other techniques.

Wash is very thin, well-diluted paint – a little pigment mixed with a lot of water. For large areas of work, add the colour to a pool of water poured into a shallow container. Always mix more than you think you will need. Test the strength of colour on some scrap paper first and if necessary strengthen or dilute further until you have the tone required.

23

24

For large areas of even colour, apply the wash with a large, flat brush – a one-stroke brush, a hake, a soft-haired 2½ cm household decorator's brush, or something similar. The principle of much watercolour work is that you always use the largest brush possible. You can use a no. 12 sable brush, but this will give a patchier sort of wash – sometimes just what you need! Wash can also be applied with a sponge.

Washes will cockle all but the heaviest-quality paper, so stretch the paper as described on page 87.

For general washes, prop the board up at a shallow angle; an old book will do the trick. Work from the top to the bottom of the paper, applying the wash from a full brush with confident, flowing strokes from one side of the paper to the other. Surplus wash may collect at the bottom of the paper but can be lifted off with a dry brush.

Wash can be applied to dry or damp paper and, of course, the type of paper will influence the result. A wash may enhance the texture of heavy-quality paper, so if you want a smooth wash you must use stretched cartridge paper.

Study the three different types of wash shown in Figures 23–26. An even wash applied to slightly damp

25

27

26

28

140 lb (300 gsm) paper is demonstrated in Figure 23. In Figure 24, a gradated wash has been achieved by strengthening the colour as it was applied to damp paper. An alternative way to do this is shown in Figures 25 and 26. Mix three strengths of colour and apply as roughly equal bands across the paper (Figure 25). Then, using a large, clean brush dipped in clean water, wet over the paper from top to bottom to blend from light to dark.

Try making a simple landscape painting, as in Figure 21, by working into and over general areas of wash.

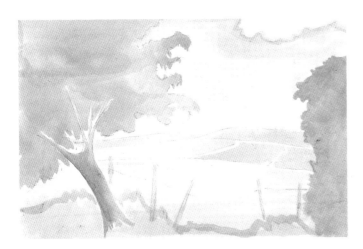

WASH EFFECTS

Confidence in mixing and using washes is vital to the watercolourist, so plenty of practice is essential. Experiment with all the wash techniques mentioned here until you really feel certain about using them. You can try them out on cheap paper, such as stretched cartridge paper or sketchbook paper. Remember that when it comes to doing the real thing you will need to work quickly and mistakes are not easy to rectify.

In addition to the general wash techniques described above, try a flat and then a gradated wash using a sponge. Natural sponges are best. You can also get a fading or gradated effect with a brush by starting with the strongest value and then simply using the brush with clean water to pull the colour down the paper. Work on dry paper to begin with, as this will give you more control. However, some wash techniques work best on damp paper, for example, various sky effects. Dampen the paper with a sponge or large brush. Avoid getting it too wet as it will quickly cockle, causing the wash to dry unevenly.

Practise using wash over wash to build up variety in the strength of colour. As an introduction to this, I suggest you mix a single wash of colour and then do a similar exercise to that shown in Figure 19 (page 22).

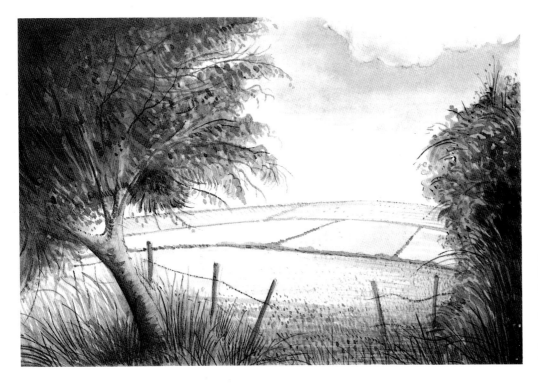

(Above)
29 Starting with some general areas of wash.

(Left)
30 Developing tone and detail with further brush and wash techniques.

This time, apply a wash to the whole area first. When it is dry, apply a second coating of wash to most of the area, then a third coating over most of that, and so on. Try to build up a range of values of colour from weak to strong.

If you find you have put some wash in the wrong place, act quickly while the paint is still wet. Weaken the area of wash with a brush dipped in clean water, then soak up the surplus paint with tissue or a dry brush. This is another technique worth practising before you are faced with the reality!

Dried wash can be worked into in a number of ways to create different textures and effects. You can reduce the strength of colour in a particular area by working into it with a wet stiff-haired brush and then drying it with tissue. This gives the effect shown in Figure 27. You can also sometimes partially remove thin, dry wash by using a clean putty eraser. Lines, textures and highlights can be made by scratching through the dry wash with a knife or lightly rubbing it with glasspaper (Figure 28).

Try a small painting like the one shown in Figures 29 and 30. Start with some general areas of wash, then work over them with further washes and brushwork.

WET-IN-WET

This is another essential skill for the landscape watercolourist. Working colour onto damp or wet paper produces diffused, subtle and, to some extent, chance shapes. This is an ideal technique for many sky effects and for creating distant, vague and atmospheric shapes.

Wet-in-wet works best on Not papers, i.e. rough, heavy-quality watercolour paper. All but the really thick papers will need stretching (see page 87). If wetted to any great extent, cartridge and some of the less weighty papers will cockle unmercilessly, making it extremely difficult to control the colour. Paint applied to cockled paper will simply collect in the 'valleys' and dry in the way shown in Figure 31. Experiment with the papers you normally use and get to know how much wetting they will take.

For most ideas, damp paper will be sufficient. Dampen the paper with a sponge or large brush, using clean water – not too much! Then apply a wash of colour. Mix the wash to a stronger strength than usual, as it will be further diluted on the wet paper. Use a

31

32

33

34

large brush and flowing, confident strokes that just touch the paper. There is no need to work the colour in with the brush. A wash applied in this way has a slightly different character to that applied to dry paper (Figure 32).

Such washes make a good foundation for developing a sky effect. In fact, instead of using clear water, you could start with a wet, weak wash of yellow ochre, raw sienna or burnt sienna, to give an atmospheric glow to the sky. While it is still damp, you

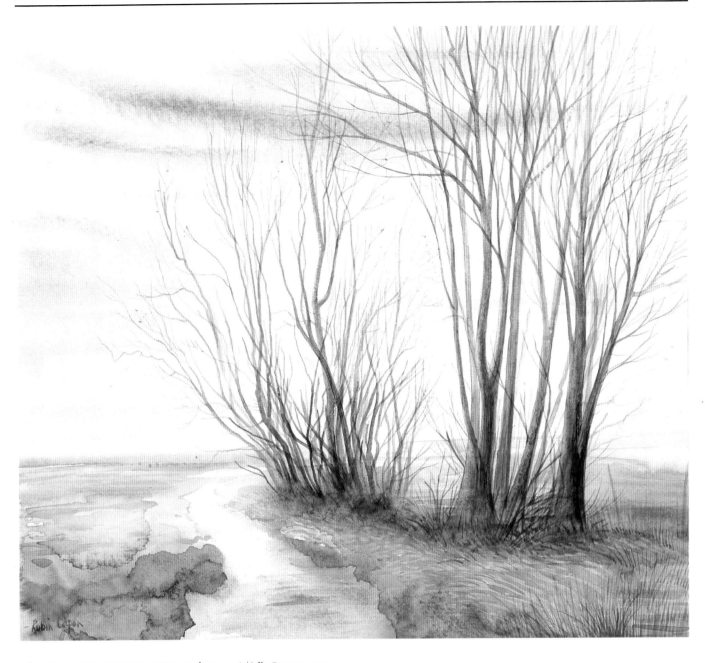

35 *Winter Mist, Dartmoor.* Watercolour on 140 lb Cotman paper.

can brush stronger pigment into the basic wash to suggest particular shapes – clouds or distant hills, for example. Bear in mind that with wet-in-wet the paint will always bleed into the surrounding area, so shapes will be soft and uncertain.

Experiment with running one colour against a contrasting colour (Figure 33) so that they fuse together. Try also holding the brush vertically over the paper and dropping colour onto a wet wash (Figure 34).

Have a go at combining some of the above techniques in a landscape painting. In Figure 35, I used only three colours: raw sienna, cobalt blue and Hooker's green. Cobalt of varying strengths was brushed on wet-in-wet for the sky area, with a weak raw sienna near the horizon. Most of the foreground uses strengths of Hooker's green and raw sienna worked into a wet base. For the trees, I used fairly dry paint applied whilst the background was still damp, to soften the silhouetted forms.

DEVELOPING WET-IN-WET

Wet-in-wet can be used in a more controlled and
confined way for softening edges and outlines. You
will need to be able to control thin lines and smaller
shapes as wet-in-wet, just as you will larger washes.
A dried wash can also be wetted with clean water and
further developed with the fusion of other colours.

Try the exercises described below to help you with
a controlled application of wet-in-wet, and then try a
landscape like the one in Figure 42 (page 29). Here
I used a high-key colour approach, in contrast to the
more subtle colour range in Figure 35.

First do some experiments with lines. For the top
line in Figure 36, clean water was brushed along one
edge of the wet line, causing it to bleed outwards.
A dry line can be softened to some extent by painting
over it with clean water, as in the middle example. The
same process applied to a wet line will cause a better
fusion of colour, as in the bottom line.

The edges of shapes can be softened by using a dry
brush to lift paint from the wet edge of an area and
then blend the colour out (Figure 37); slightly wetting
along the edge of a shape (Figure 38); re-wetting the
whole shape with clean water (Figure 39); using a
wetted hog brush to scrub into the edge of a dry shape,
re-wetting and blotting with tissue (Figure 40); or
dabbing the edge of a wet shape with tissue paper
(Figure 41).

38

39

40

36

37

41

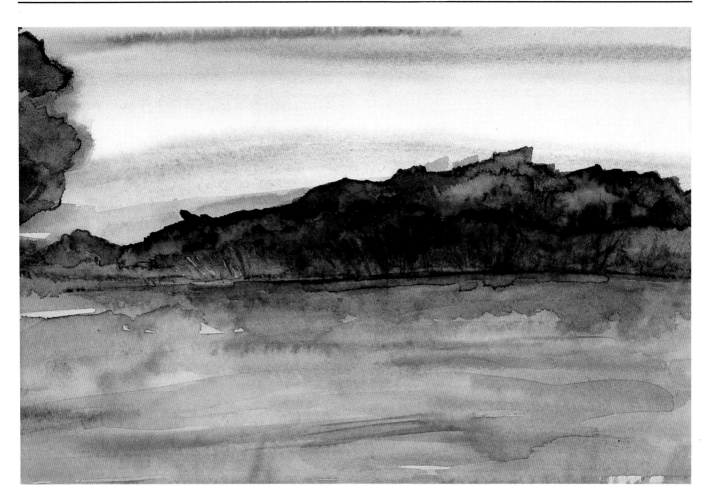

42 As in this landscape, wet-in-wet can be powerfully *expressive*.
Compare this to the *suggestive* approach in Figure 35.

DRY BRUSH METHODS

As the name implies, dry brush is a technique in which
thick pigment, or a brush bearing just a hint of diluted
paint, is applied to dry, rough-textured paper. The
paint catches the 'tooth' of the paper, creating a
textured effect, with some parts remaining white. You
can use paint straight from the tube, or mix it with just
a little water.

You will see from Figure 43 that you can use dry
brush methods over white paper, so that the white
gaps add to the effect you are trying to achieve, or over
thin washes of colour. In the main, dry brush strokes
need to be applied with vigour. They are good for
giving the impression of something, for suggesting
surfaces and textures rather than involving a lot of
highly worked detail. You could paint an entire picture
using a variety of dry brush techniques, but more

likely some of these effects would be combined with
wash, wet-in-wet or other approaches.

Like any new technique, it is well worth doing a
series of experiments to gain some confidence and
find out for yourself what sort of effects are possible.
Try out some different brushes and various types of
paper. As well as the usual pointed watercolour
brushes, try a stiff-haired hog brush and a fan brush.
Although rough-surfaced paper will enhance the
results, interesting effects are also possible on
cartridge and other types of paper. Because very little
water is used in the paint mix, it is not necessary to
stretch the paper.

Try these two ways of loading the brush with paint.
Dip the brush in water, then wipe it almost dry before
picking up some undiluted pigment. Alternatively,
load the brush with mixed paint in the normal way,
then dry it with some tissue so that very little paint

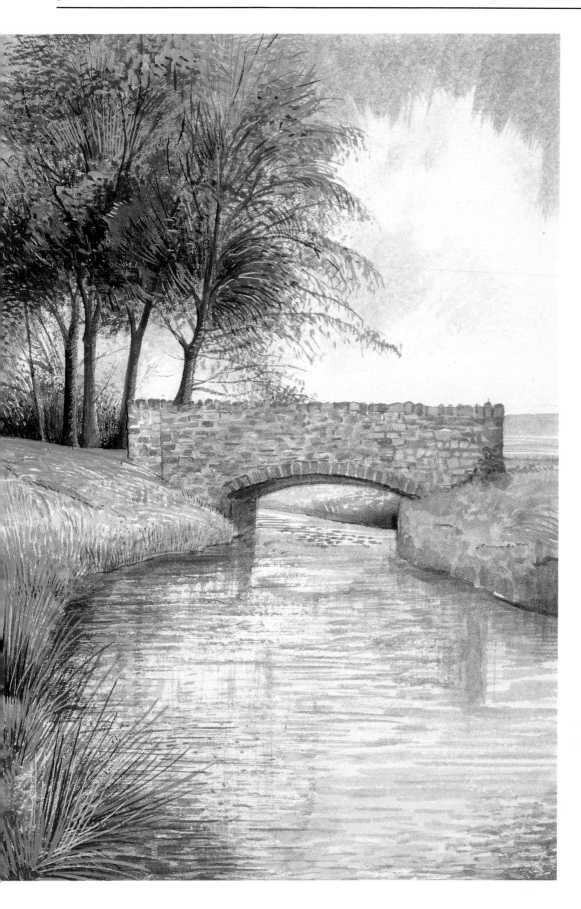

43 *Litton Water, Withypool Common, Exmoor.* Watercolour on Saunders Rough paper.

remains. Use the brush in a variety of ways (Figure 44). Drag the brush lightly across the surface of the paper, roll it from side to side, stab, stipple, and so on.

See what dry brush effects you can invent before tackling a painting. See if you can match the effects to different surfaces, such as sky, water, foliage or an old stone wall.

44

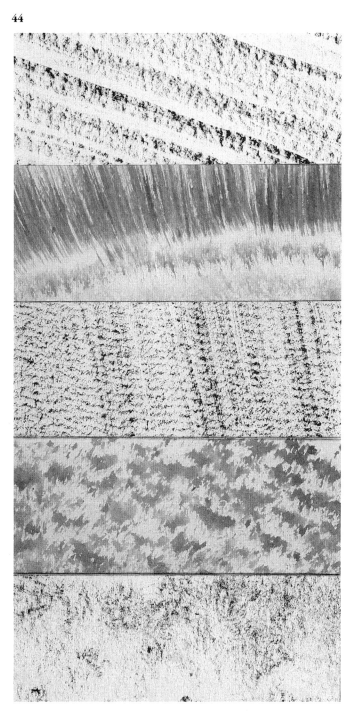

OPAQUE EFFECTS

Traditional watercolour techniques aim to use colour in such a way that it transmits light, thereby achieving the translucency characteristic of the medium. The white of the paper plays an important part in this process, influencing the quality of colour, enhancing colour and creating highlights. Where white patches are deliberately left, they can create a distinct element in the design or composition of the work.

Sometimes, the nature of the subject matter demands a contrast between weak, translucent washes and areas of more solid, opaque colour. Although it is possible to build up dense colour by a succession of washes, many artists prefer to combine watercolour pigment with gouache in order to extend their range of painting techniques.

Gouache, sometimes called body colour, is made in a similar way to transparent watercolours. However, to make the paint film thicker and more flexible, extra

45

46

47

48 and **49** *Harvest Poppies*. Watercolour and gouache on stretched cartridge paper.

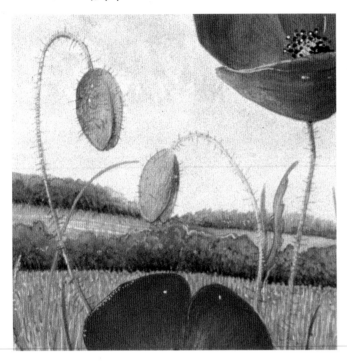

glycerine is used. Although gouache colour is less brilliant than true watercolour, it has the ability to flow freely and to brush out in flat areas of colour. Also, re-wetted areas painted with gouache easily become soluble and thus can be re-worked or blended with surrounding colours. Gouache is also good for dry brush work and thins well for use in an airbrush.

Your watercolour palette can therefore be supplemented with a few tubes of gouache. When I use gouache in landscapes, I confine it to the use of permanent white. This I find helpful for achieving various sky effects; for creating thick, textured, dense or body colour where I need it; for mixing with other colours to create particular tints; and in overpainting as pure white.

Try for yourself one or two simple exercises to explore the contrasts between watercolour and gouache, and how the two can be usefully combined. Start with three test pieces like the ones shown in Figures 45–47. Figure 45 shows a wash of cobalt blue made with watercolour. Notice how the light of the paper comes through the colour wash. The colour sample in Figure 46 was made by mixing the same cobalt watercolour pigment with some permanent

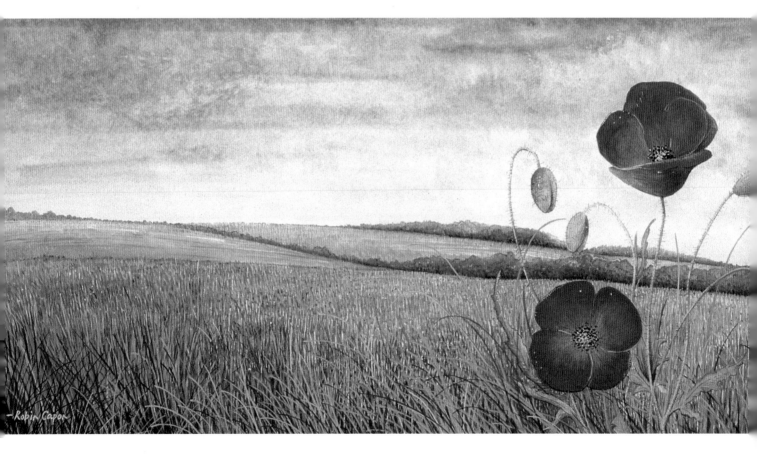

Designers' White gouache. Most of the area is dense, opaque colour, although I have deliberately left the middle thinner to show that, even with gouache, weaker colour with some transparency is possible. Figure 47 shows white gouache painted over a dried area of watercolour wash. Watercolour and gouache paints mix readily together, and one way of making any colour opaque is simply to add white to it.

All of these opaque effects are used in the painting shown in Figures 48 and 49. Here, preliminary watercolour washes have been overworked with opaque colour and white gouache. The sky has had white gouache worked into it to add texture and, similarly, the detail of the foreground uses 'fat' colour made by mixing watercolour pigment with white. Have a look also at Figures 1, 4, 55, 104 and 115.

WASH WITH LINE AND TONE

Thin washes of colour work well with many drawing techniques. The structure and details of the composition can be worked in ink, pencil or another drawing medium first, and then enhanced and enlivened with tints of colour. If until now your work has mostly been in the form of drawings, this is a good way of introducing yourself to watercolour. As you gain confidence with handling washes, you may be able to dispense with the drawing altogether. Some artists find watercolour too loose, and therefore by drawing into the washes with line they achieve the sort of definition they want.

With any combination of techniques it is always as well to make a few experiments first. Most drawing

50

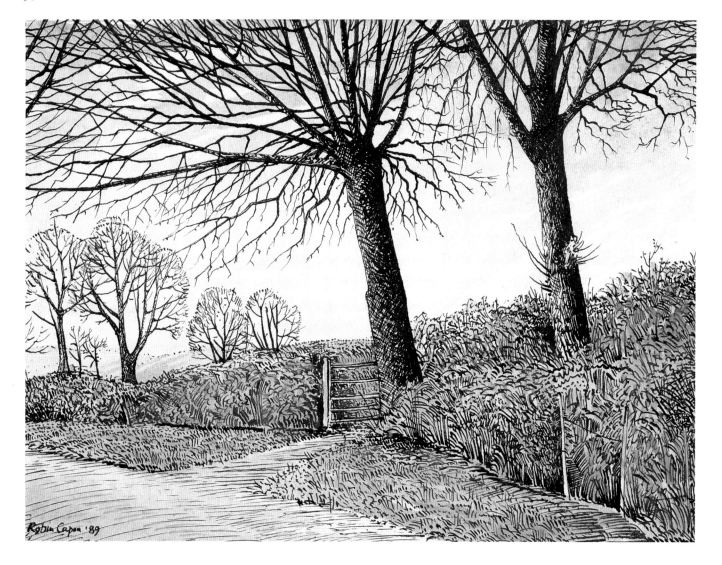

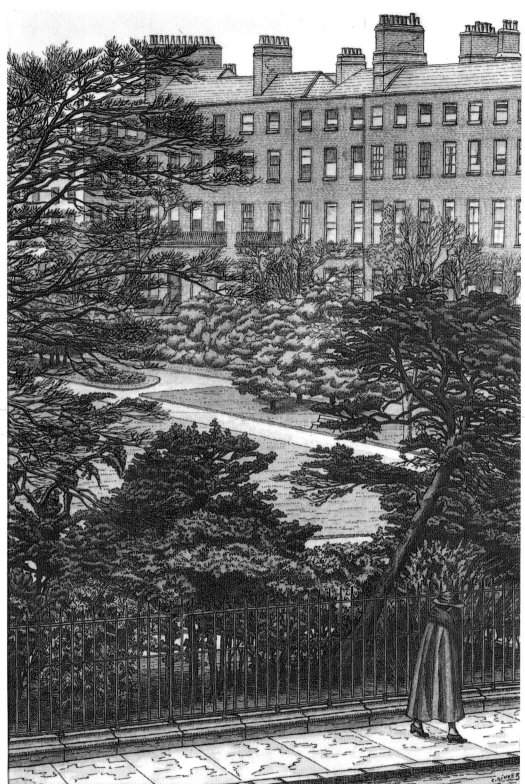

51 *Fitzwilliam Square, Dublin, 1923* by Charles Ginner. Ink and watercolour on paper. (British Council)

media will combine with wash to some extent, but it is advisable to find out just how much before you slap a wet wash over the whole drawing only to find that it all disappears! A good combination is pen-and-ink with wash. The wash can reduce the sometimes stark contrast between the positive areas of the drawing and the negative white spaces, as in Figure 51.

In Figure 50, I started by making a pen-and-ink drawing, using a mapping pen and Indian ink. I did not use any preliminary pencil drawing, although you can if you wish, especially as pen-and-ink work requires some confidence as it cannot be erased. Notice the variety of ink drawing techniques, from solid shading to hatching and various dots and dashes. Leave the drawing to dry before adding any washes. Indian ink is permanent and therefore will not be affected by the subsequent application of wet washes. In this painting, I used gouache paint of various consistencies with some shading in coloured pencil. Other inks are soluble and would therefore bleed or blur slightly if wetted. This is a characteristic which can be used to advantage in some misty, watery or looser types of subject matter. Watercolour washes can similarly be used to develop line drawings made in pencil or coloured pencil.

Alternatively, a study begun with preliminary areas of wash can be overworked in various ways with several different media. Block in the areas of wash first and leave them to dry. You can then draw and shade over these coloured areas with charcoal, pastel and various types of pens and pencils. Water-soluble coloured pencils have the added advantage that they can be wetted and blended into the underlying areas of wash where necessary.

Try out all of these techniques and make one or two studies which use a mixture of effects. Work on stretched paper (see page 87), and experiment with coloured paper. Look also at Figures 56, 57, 62, 69, 101, 102 and 103.

MAKING TEXTURES

The typical watercolour landscape is characterized by a feeling of space, light and atmosphere. Treatment is often delicate and suggestive, rather than involving any obvious painterly quality in the handling of colour. Yet, in fact, watercolour can be surprisingly versatile. It can be combined successfully with a variety of media

and techniques, particularly gouache. In addition, there are a number of ways of mixing and applying watercolour which allow the surface of the paint, or texture, to become an interesting, perhaps even dominant, feature of the painting.

Like any other subject, landscape evokes different responses from different artists. One artist may be struck by broad forms of colour, or of light and dark; another may be intrigued by the rippling surface of water, or the detail in a hedgerow. It is all a question of

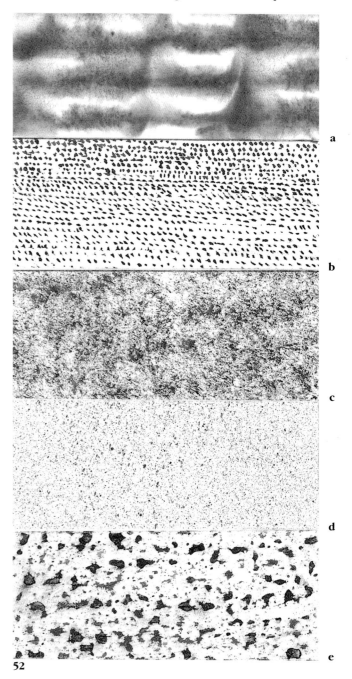

a

b

c

d

e

52

seizing on those qualities which seem important to you and interpreting them to the best of your ability.

If, like me, you are fascinated by the immense variety of surfaces and textures in landscape, then it is well worth developing a number of brushwork techniques which will help you convey these in your paintings. As always, it pays to experiment with these techniques first, so that when it comes to actually using them you are brimming with confidence and skill. Remember to see how they react on different types of paper, and test them out on some spare paper first.

Work through the five texture techniques shown in Figure 52, then try and develop some other effects from these. The effect shown in (a) was achieved by

lightly brushing paint onto wet paper. In essence, this is therefore a controlled wet-in-wet method. Load a no. 4 or no. 6 brush with paint of a medium consistency and apply it with a slight flick of the wrist, so that it just touches the wet paper. Repeat as necessary to cover a particular area. For (b), use a fine, pointed brush. Hold it vertically and gently stab down as you work your hand across the paper. A stippled effect is used in (c). This is made with a stiff-haired hog brush, again held vertically, but loaded with just a little, fairly dry paint. In (d), a spattering technique was used. Dip an old toothbrush or stiff-haired brush into some paint, hold it directly in front of the part of the painting you wish to treat, and pull back the bristles with your

53 *Peppercombe Beach, North Devon.* Monochrome watercolour study with wax resist.

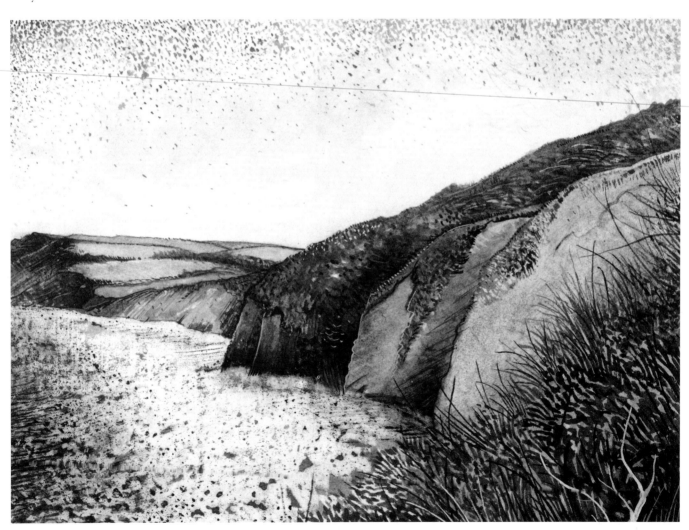

forefinger to create a shower of fine spray. For (e), first coat the paper with a layer of white or clear wax. Use a wax crayon or candle. Then paint over with a fairly thick wash to give the sort of wax-resist effect shown.

Most of these techniques are combined in the painting shown in Figure 53. Notice how they can be integrated with basic areas of wash. As you come across different landscape surfaces and textures, consider the best means of depicting them in your work. Have a look through the illustrations in this book and see how different artists have dealt with the textures of landscape.

USING MASKING FLUID

A problem for all watercolourists is how to deal with the white areas of the painting. There may be highlights which you need to leave white or a very weak colour. There are also particular shapes that you wish to leave unsullied by general washes so that you can return to them with pure colour, rather than colour compromised by preliminary treatment.

There are three main options for creating white in a watercolour: leaving the white of the paper, masking out and overpainting with white gouache. In a real emergency, paint can be removed by wetting and lifting (as described on page 26), but the success of this will depend on the type of paper and the particular colour used. This technique will usually leave a stain of colour rather than a positive white.

I am not a great advocate of the use of masking fluid, but there are situations where it is an advantage. If you have a large expanse of wash, say a sky area, but within it there are one or two specific shapes that you want to leave, then these are more easily treated with masking fluid rather than trying to carefully paint round them. Normally, a wash must be put on quickly and with broad, flowing strokes, so manoeuvring round the intricate shape of something is difficult. Likewise, thin lines, dots, textures and small details are sometimes better masked out than trying to remember where to leave a white space.

Masking fluid is obtainable from all good retailers of artists' materials. It is a rubber latex solution which can be painted onto appropriate areas of the work, using an old soft-hair brush. The fluid works best on dry, surface-sized paper, rather than softer, very absorbent papers, on which it may stain and prove difficult to remove without tearing. If you have any doubts about

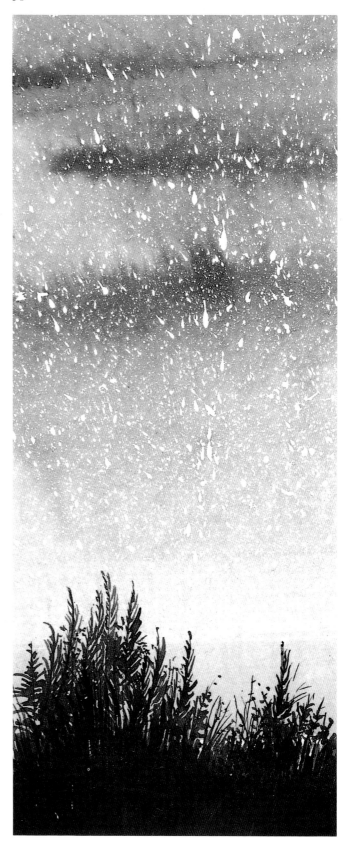

54

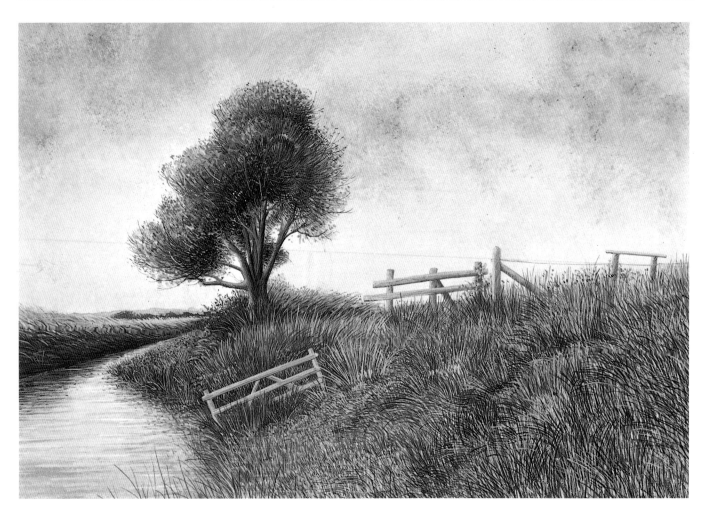

55 *Romney Marsh, near New Romney.* Watercolour, gouache and masking fluid on stretched 90 lb paper.

the suitability of the paper, test the fluid in one corner first. One coat is usually sufficient, but use two if you need a really solid white. Make sure the work is entirely dry before rubbing off the solution with your fingers. Although it is usually worked in at the beginning of a painting, masking fluid can be used at any stage to preserve an area or colour from subsequent washes. Intricate shapes can be lightly pencilled in first. Clean the brush immediately in warm, soapy water.

In Figure 55, I used masking fluid to retain the lights in the water and to keep plenty of fine, light lines in the long grass of the bank. Masking fluid can also be useful for sky effects (see page 72) and for creating different textures. In Figure 54 the masking fluid was applied with a spattering technique, using an old toothbrush (see page 18). When a wash was painted over this, it created the speckled effect shown.

MIXED MEDIA EFFECTS

Purists would probably find any concoction of different media abhorrent and this, understandably, applies to mixed media techniques with watercolour. Those who work in a traditional way naturally regard the use of pencil or pastel in a watercolour as quite unthinkable. Some take the view that a medium is used for its particular qualities, and should not rely on the support of others. However, whilst respecting those views, there are times when I think it can be a positive advantage to use mixed media techniques in order to convey a subject as sympathetically as possible, or to give the picture some extra excitement and impact.

Several media work very effectively over preliminary washes of watercolour. I suggest you try these out in sketchbook form first so that you get the

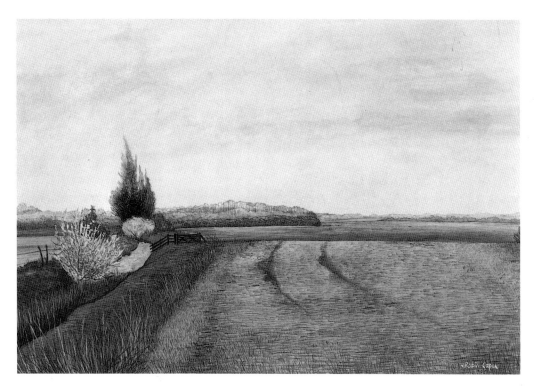

56 *Spring Marshes, North Kent*. Mixed media: watercolour wash, pastel, pencil and coloured pencil.

57 *Sunset Hedgerow*. Mixed media: watercolour wash, ink, pastel and charcoal.

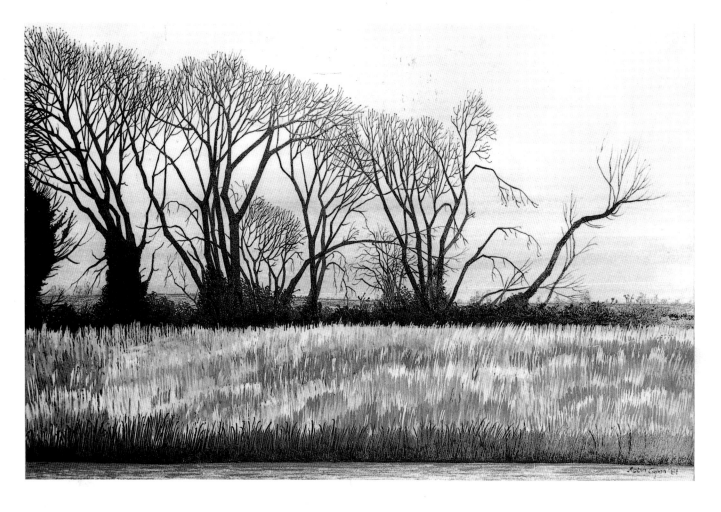

feel for them before attempting any larger and more resolved work. Pencils, inks, pastels and charcoal can all be worked over areas of watercolour. Success with mixed media techniques depends not only on selecting a combination of media which interact well, but which also suit the different surfaces and characteristics of the particular landscape.

In general, work on heavy-quality stretched cartridge paper, as this suits most combinations and techniques. If you wish to make something of the texture of the paper, for example with pastels and charcoal, use a heavy or rough watercolour paper. A reliable and very effective mixed media colour technique is to use watercolour washes worked over with pastel and pastel pencils. Build up the basic tones with various washes of colour in the normal way and then apply the pastel. Use the pastel sparingly, working it into the surface by rubbing it with a finger or a piece of cloth or cottonwool. Blend colours as necessary, gradually building up the strength of tones. Work from

background to foreground to avoid smudging completed areas. You can work into the pastel with an eraser to make highlights, using a pastel pencil for fine details and sharp edges. A combination of charcoal and pencil works in a similar way. Spray the completed work with fixative.

In quite a few of my watercolours, I develop the work with other media. Two examples are included here to show different approaches. In Figure 57, I was struck by the intense contrast between the silhouetted trees and the weak, dying sunset beyond. I decided to make the most of this by defining the trees as stark shapes drawn in pen-and-ink, whilst the weak washes in the sky area were only slightly enhanced with some pastel. The middle-ground is shaded with charcoal, and the foreground has a mixture of pencil and paint techniques. In Figure 56, the watercolour wash has been combined with a treatment mostly in coloured pencils to create various textures and detail.

Finding Inspiration and Ideas

- Types of landscape -
- Sketching out of doors -
- Taking photographs -
- Location painting -
- Inspiration from other artists -

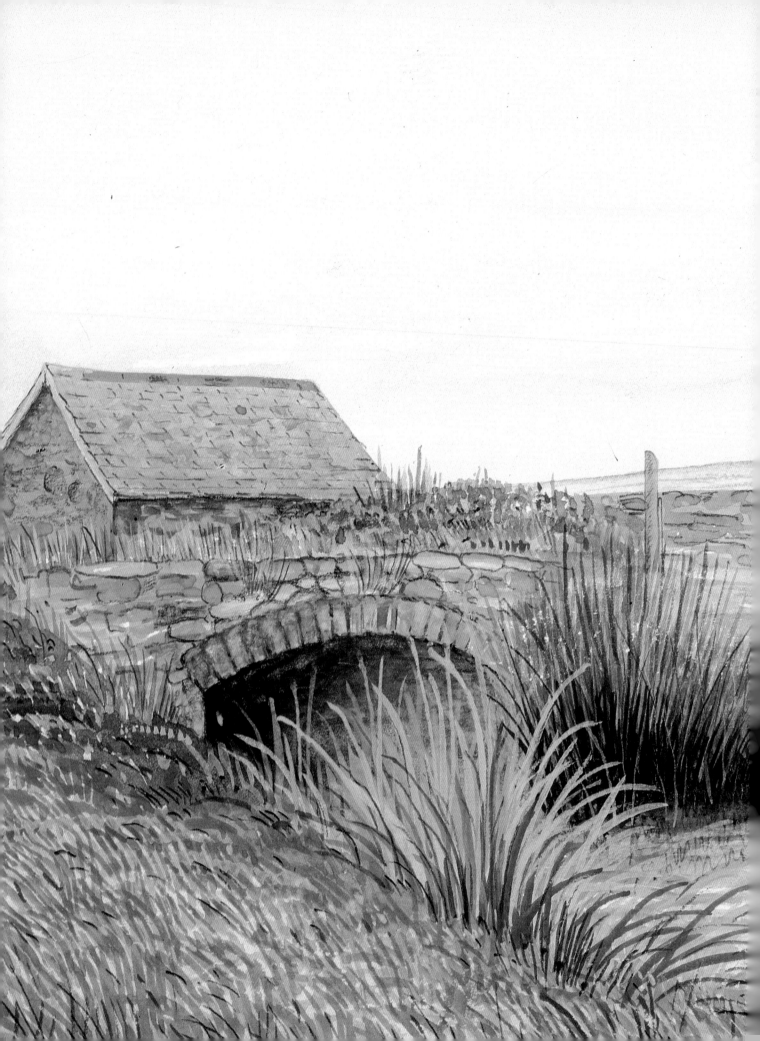

3

Finding Inspiration and Ideas

WITH THE range of techniques explained in Chapter 2 and the variety of landscapes and wealth of ideas, there would seem little difficulty in finding inspiration. Landscape sounds like the ideal subject matter – it doesn't move, it doesn't need a rest every fifteen minutes, and you don't even have to use any imagination. The weather is always an unknown quantity, but you can go back the next day and find that your landscape hasn't wilted, run away or started to smell!

Nevertheless, the business of working outside and the problems of composition, form, space, depth and colour can be formidable. Once you have become a passionate landscapist, you will see so many possibilities for exciting pictures that you will not know where to start. Certainly, enthusiasm is a key factor. You will know from your own experience that something which you find stimulating and challenging, and which you feel strongly about and really want to do, is much more likely to succeed than something you have felt obliged to do. Because of the variety of landscape topics, there is value in developing your experience by a catholic approach but, equally, it is worth exploring a personal theme in some depth.

So where does inspiration come from? Do we sit with paintbrush poised, waiting for it to strike from above? If we do, then we may have to sit for a very long time! It is true that sometimes when we are outdoors, probably when we are least prepared, we have an idea or see a view which immediately strikes a chord and fires us with excitement and ambition. At once we see the potential for a really great painting and we want to get on with it. However, for the most part, we need to work at finding inspiration. It helps to expose yourself to a wide variety of ideas and situations, and build up as much experience as possible. Get to know the countryside by walking in it, by sketching out of doors, by taking photographs and by making location paintings. Like any type of painting, success is linked to

knowledge of the subject. You need to be out in the countryside as often as you can to establish a feeling and affinity for the landscape.

Look at the work of other artists too. There is no harm in pinching one or two ideas if you put your own emphasis and interpretation on them. Relate all this to the variety of techniques available, and the scope for ideas is boundless!

TYPES OF LANDSCAPE

Figures 58 and 59 show two very different landscapes. Some of us are impressed by the beauty and solitude of unblemished Nature, others are intrigued by the contrast between man-made and natural environments. A working quarry is a landscape, just as are acres of downland, remotest glen or deepest woodland. An interesting landscape can be a city garden (Figure 51) or a ploughed field (Figure 3). You can concentrate on a single feature (Figure 115) or consider a panoramic view (Figure 2).

The landscape you choose to paint will reflect what appeals to you, but try not to confine yourself to repeating a certain landscape type. Get out there and explore everything!

SKETCHING OUT OF DOORS

Understanding is an important aspect of any type of creative work. You will not make a very good landscape painting from just a few cursory glances. Instead you have got to look hard and really try to appreciate the various shapes, structures, colours, textures and so on. The best introduction to landscape for the beginner, as well as a good way of getting to understand the likely problems, is to do some on-the-spot sketching.

Location drawing is a good habit to get into. You will not always be able to paint outside, and very often when you come across an interesting idea you will not have your painting equipment with you, or the time available. But you can carry a pocket sketchbook and make a quick drawing, or jot down a few notes. At other times, you can go out to collect specific research information for a painting which you intend doing back in the studio. As a preliminary to any painting, it is a good idea to make a sketch, to help you establish a basic understanding of the subject and to define its broad composition.

You can work on separate sheets of paper or an A4 cartridge sketchbook, as you prefer. Most people are accustomed to drawing with pencil, so by all means start with this. Use a soft sketching pencil or a 4B or 6B drawing pencil. Try to exploit the possibilities of the medium to suit the characteristics of what you see, as I have done in Figure 60.

Pencil drawing will help you analyse what you see, but colour drawing can be infinitely more helpful if you are going to take the work back and translate it into a painting (see page 88). Do not be afraid to try out other techniques as well. This can add to your experience and enjoyment, and pencil or crayon is not always the best technique for interpreting what you

58 (Above)

59 (Left)

60

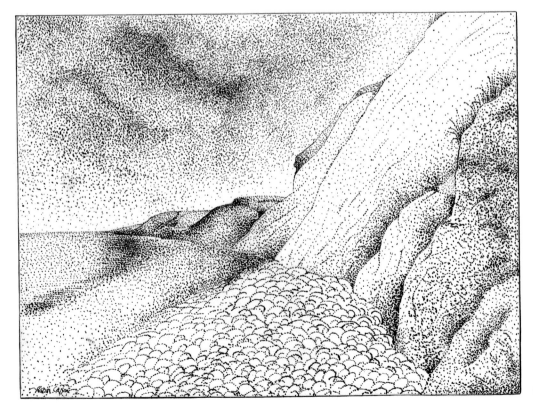

61

see. My alternative drawing in Figure 61 is done in pen and ink, and Figure 62 uses a combination of monochrome techniques – wash, pencil, ink and masking fluid (see also pages 38–40 and 77–9).

If you intend to use a location drawing as the preliminary work for a subsequent painting, then obviously some colour reference is very helpful. Monochrome work can have written notes added to help identify and suggest colours, but ideally make the drawing itself in colour so that you have a more direct indication.

When you have plenty of time and want to make a carefully observed and fully resolved study, use coloured pencils, as shown in Figures 63 and 64. Water-soluble pencils are in some ways more useful,

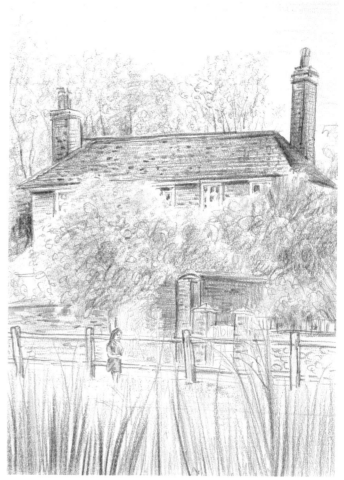

63 Location study using coloured pencils.

as shaded areas can be wetted to give wash effects with a result similar to an actual watercolour. Another recommended medium is pastel. This can be used very quickly, giving a feeling for form and atmosphere which readily translates into watercolour.

Sometimes the briefest of drawings has to do, or you may feel it unnecessary to labour over a detailed study when all you need are the bare bones. This is especially true when you are sorting out a basic composition which you intend to work up as a painting. On other occasions you may be caught in a heavy shower or run out of time. So do what I have done in Figure 65: put in the main lines of the idea, give some suggestions of different surface areas, and add written notes to remind you of the rest. As you gain experience, this sort of drawing can be developed into a sort of personal shorthand and is particularly appropriate for the pocket sketchbook.

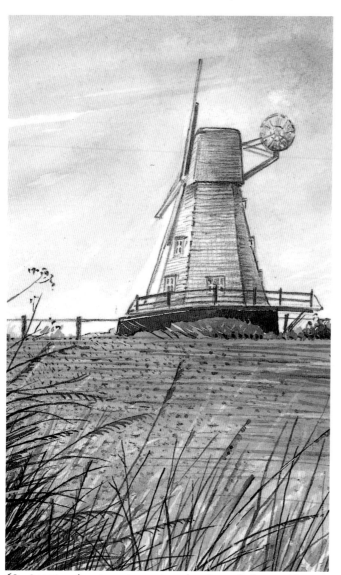

62 Location drawing using various drawing techniques with masking fluid.

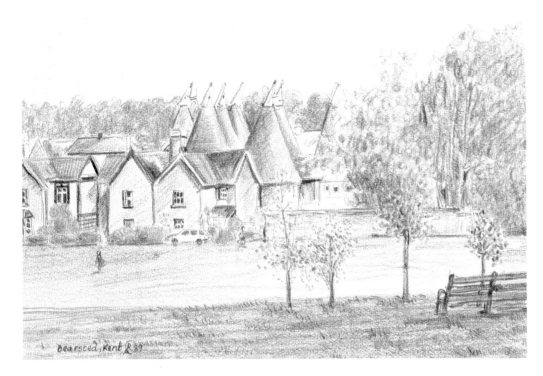

Bearsted, Kent '89

64 Drawing in colour will give you more information to paint from.

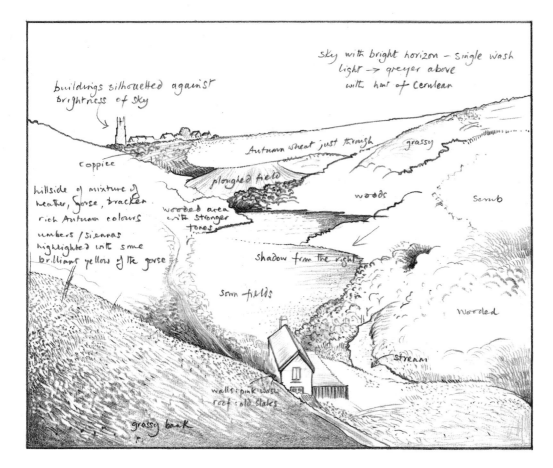

buildings silhouetted against brightness of sky

Sky with bright horizon – single wash light → greyer above with hint of Cerulean

coppice

Autumn wheat just through grassy

ploughed field

hillside of mixture of heather, gorse, bracken rich Autumn colours umbers / siennas highlighted with some brilliant yellow of the gorse

wooded area with stronger tones

woods Scrub

shadow from the right

sown fields

Wooded

walls: pink wash roof: old slates

stream

grassy bank

65 A sketchbook drawing with added notes.

TAKING PHOTOGRAPHS

This is another topic which attracts opposing attitudes from different artists. The justification for using photographs and what value they can be is a matter for individual assessment. We each develop our own philosophy about painting and establish a personal process of working. For some, photographs can play an important role.

I would not advocate photographs as the sole means of inspiration, but I think they can save the artist valuable time and provide useful starting points and reference detail. Certainly, the photographs must be your own, because the subject must be viewed through your eyes and because you need to balance any photographs with first-hand experience. If the weather is particularly bad, it may be tempting simply to take a few photographs rather than to persevere in the cold or wet, but try to support them with some quick sketches or notes. A range of angles can be useful to give different composition ideas, and close-up photographs can help with details. There are also those fleeting moments when we do not have the time or the equipment to make a sketch or painting. Use photographs in a supporting way, as a means of adding to your own location drawings, notes and observations.

Bear in mind that photographs can be misleading. For example, colour quality in photographic prints is not always very accurate, so jot down some colour notes or quick pastel sketches as more reliable reference. Photographs tend to retain detail in background areas, and this often has to be simplified in a painting. Perspective is frequently exaggerated in a photograph and the effect of aerial perspective on distant colour is often not very apparent.

You may have a photograph like the one in Figure 66, which shows exactly the composition you want to enlarge and develop as a painting. If so, you can square it up (see Figure 67) to help you transfer it onto a larger sheet of paper. This method can also be applied to any small preliminary drawing or colour sketch.

Use a sheet of paper which is in proportion to the smaller image. Cover the photograph or drawing with tracing paper to protect its surface and draw a grid of squares over it (Figure 67). Keep the squares to a reasonable size, say 2.5 cm, otherwise the process becomes too complicated and time-consuming. The photograph may not divide exactly into the number of squares; there may be a bit over. This does not matter as long as you do the same on the larger sheet of paper. Using very faint lines, draw a similar grid on the larger sheet, using the same number of squares. Referring to the original image, take each square in turn and re-draw the part of the drawing in that square on a bigger scale, to fit the corresponding square on the large sheet. When this process is complete, you can rub out the grid and begin the painting.

LOCATION PAINTING

'The bad weather prevented my working on the spot, and I've completely ruined it by trying to finish it at home. However, I at once began the same subject again on another canvas, but, as the weather was quite different, in grey tones and without figures.' So wrote Van Gogh in one of his many letters to his brother Theo, expressing some of the difficulties of painting out of doors.

The main problem is the light, especially if you want to work on a subject for any length of time. Shadows change, influencing tones and probably the colour key of the whole picture. A sky can completely change in character within the course of half an hour. For these reasons, few artists paint their main works on the spot, preferring instead to work up ideas in the studio from sketches, notes and photographs. In the comfort of the studio, surrounded by all your equipment and with as much time as you need, you can be confident of doing a good job.

However, much of the inspiration for a painting comes from first-hand experience of the landscape. Whenever possible, it is a good idea to get out and do some location painting. These paintings do not always work and are not always completed, but they provide stimulating ideas and reference material, and the opportunity to be at one with the landscape – something you cannot do in a studio. As well as being good for your work, this outdoor experience is good for your spirit too!

Take whatever equipment you think you might need, including something to sit on. Remember that equipment can be heavy and difficult to carry if you have to walk any distance, so keep it to a minimum. You will not need an extensive palette or dozens of brushes. Stick to a small box of watercolours, two or three different-sized brushes, and a watercolour pad

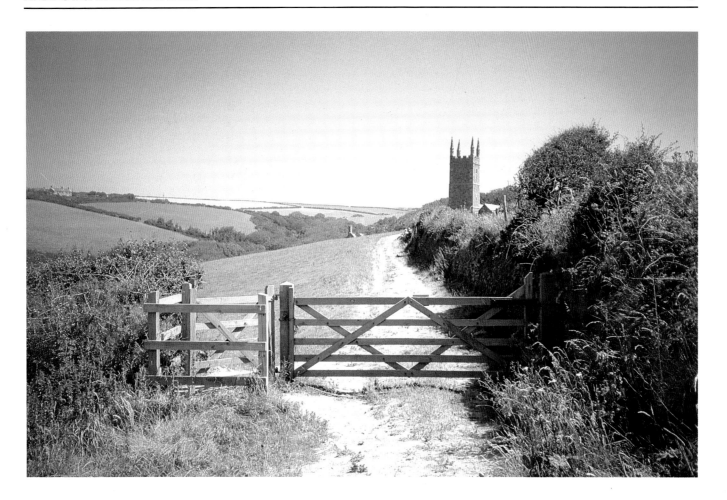

66

67

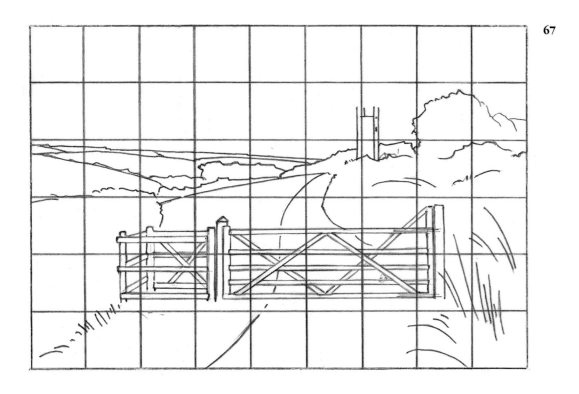

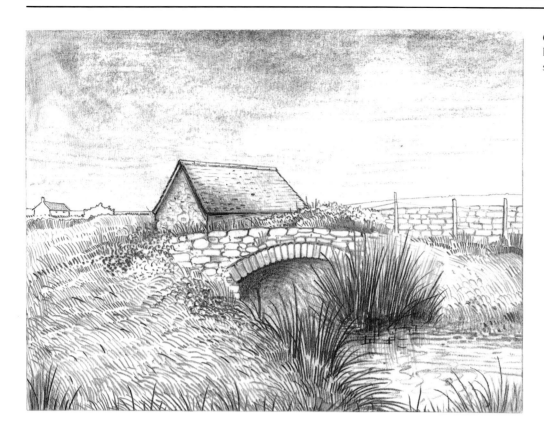

68 Start with a drawing to help you understand your subject.

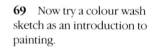
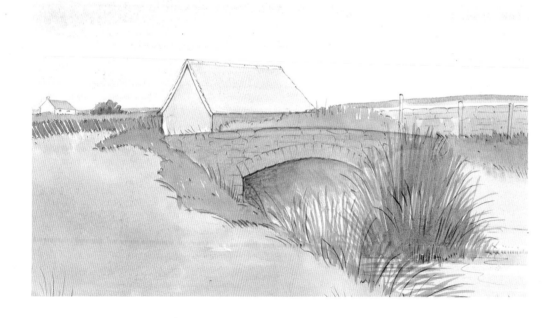

69 Now try a colour wash sketch as an introduction to painting.

or block. Have some waterproof protection ready for the work in case it rains, even if you forget an umbrella for yourself!

Like Van Gogh, be prepared to alter your plans if the weather changes. Try several smaller, quick studies rather than one large, more detailed one, or do some sketches of changing cloud formations, shimmering trees, and so on. There is always plenty to paint. Do not forget that much of the painting process is looking, observing and understanding.

Given a settled sky and a long, fine summer's day, you should be able to produce some quite finished work. Even on an unsettled day, it is usually possible to shelter somewhere and the need to work quickly will often stimulate some dramatic ideas. My own approach is to make the most of such occasions to get a variety of informative colour sketches from which to develop final paintings later. When possible, I like to start with a pencil drawing, as in Figure 68, as this really helps me to look at and understand what is there. Then I might make a colour wash sketch, as in Figure 69, before working on a more detailed colour study, like the one in Figure 70.

70 *Braunton Marshes.* Watercolour on 70 lb (150 gsm) Bockingford watercolour sketching paper.

INSPIRATION FROM OTHER ARTISTS

Sometimes an idea comes from looking at the work of other artists. I'm not suggesting you copy someone else's paintings, but when you notice a particularly interesting use of technique or approach you might try it out for yourself. Notice, for example, how watercolour painters tackle skies, or use light and shade, or different wash effects. You may come across some new ideas for subject matter, or be encouraged to try more dramatic compositions. Sometimes, just a slight adjustment to your approach can open up a wealth of fresh possibilities and a new phase of development in your work. This will help keep your paintings alive and vigorous. Sticking to the same well-worn ideas and methods will only result in tired, uninspired results.

An important quality in a painting is interpretation – that personal mark of the artist which distinguishes his paintings from others. Interpretation may be linked with a certain technique or a particular subject matter, but it can also result from the way the paint is handled or the way the painting radiates mood and atmosphere. One good reason for studying the work of other artists is to see how they have interpreted landscape and whether you can learn from their achievements.

Of course, the beginner has a lot to cope with when attempting a painting. Not only are there many technical problems, the landscape subject matter itself can seem daunting. But as you gain experience and begin to wrestle with and overcome these various difficulties, you will want your paintings to make more of a personal statement. Although I have covered many different ideas and techniques in this book, the results are all based on a conventional interpretation of

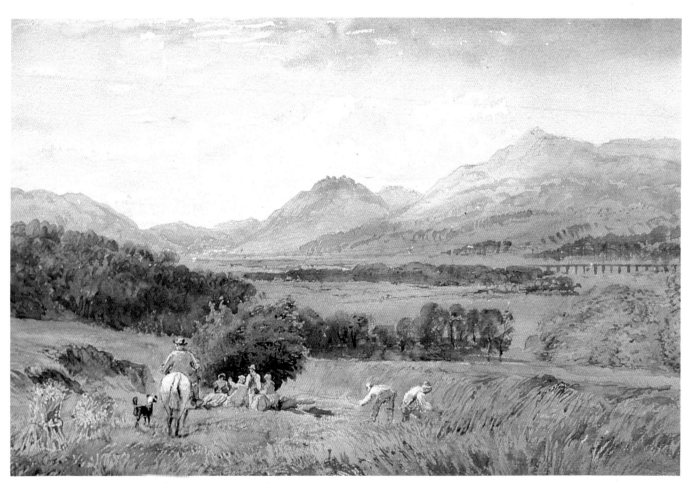

71 *Vale of Llangollen* by David Cox Junior. Watercolour. (Blackburn Museum and Art Gallery)

landscape as I believe this is the only way for a
beginner to approach the subject. However, there is
no reason why you should not adopt an abstract or
freely expressive approach. In your paintings, it is your
ideas and your interpretation that count, so don't be
afraid of being individual or different!

Whenever you have an opportunity, do try and look
at as many landscape watercolours as you can. View
them in an enquiring way and see what you can learn
from them. Look at reproductions in books by all
means, but there is no substitute for the real thing so
when possible visit a gallery or an exhibition. See, for
example, the two wonderfully contrasting landscapes
in Figures 71 and 72, and look at the Introduction and
Chapter 7 for other paintings by well-known artists.
Try to analyse each artist's individual approach to the
landscape.

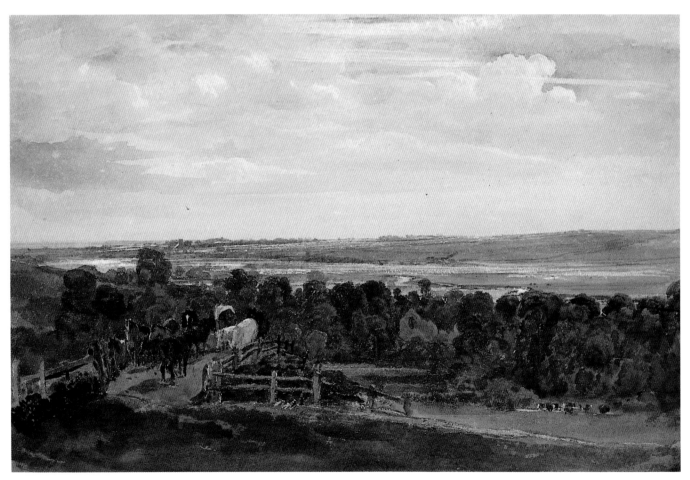

72 *A Lincolnshire Landscape* by Peter de Wint. Watercolour.
(Williamson Art Gallery and Museum, Metropolitan Borough of
Wirral)

Thinking About Composition

- Selecting an idea -
- What is good composition? -
- Experimenting with composition -

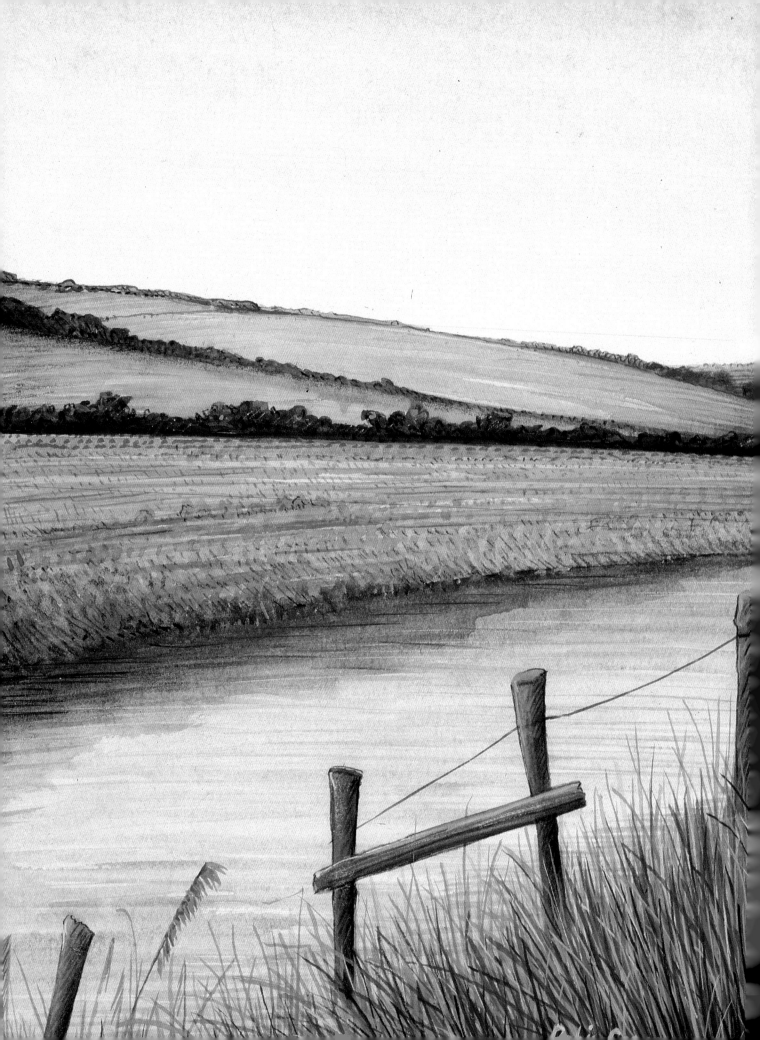

4

Thinking About Composition

COMPOSITION is the arrangement of the main shapes within the picture. As with any work of art, the basic design or composition of a landscape painting is a crucial factor in its ultimate success or failure. Although we may eliminate some things and emphasize others, most landscape paintings are a fairly accurate representation of what is actually there. In effect, therefore, the composition is usually ready-made. The problem for most landscape artists is selecting that special part from the scenic beauty that surrounds them – the part that is going to make the most exciting and telling picture. Isolating one area of a landscape from the rest and then concentrating on it isn't always easy!

In looking for that interesting piece of landscape, you need to bear in mind some fundamentals about composition. Generally, you want an idea which is uncluttered, which has some contrasts between bold and weak forms and colours, which conveys a sense of scale and mood, which has a dominant feature or focal point, and which will maintain the viewer's interest within the bounds of the picture. Remember that the sky area is an important, integral part of the overall design.

SELECTING AN IDEA

The abundance of shapes and details in a panoramic landscape can make it very difficult to find any real structure for your painting, or to isolate one part for particular study. These three approaches will help you solve these initial problems:
1. Look at the landscape through half-closed eyes. This will help you block out unnecessary detail and see the main elements of composition.
2. Mask out an area of the landscape with your hands to check whether it is what you want. With the backs of your hands facing you, hold up one hand vertically and

the other horizontally with both thumbs outstretched at right-angles. Overlap your hands until the tips of your thumbs touch. You now have a rectangle through which to view the landscape. Move it to and fro and from side to side to check alternatives.
3. Make a cardboard viewfinder similar to that shown in Figure 74 and carry it around with your sketchbook. Cut a rectangular hole about 50 mm x 80 mm in a small piece of card. If you hold it up to the landscape, you can find a section (Figure 73) which can be enlarged for a preliminary idea (Figure 75).

WHAT IS GOOD COMPOSITION?

Like any aspect of painting, there is no specific formula which guarantees a successful composition. What suits the personal style of one artist will not necessarily work for another. The information and advice in the next few pages should help you to improve your awareness of composition, and show how important it is to spend time planning your work. There are plenty of composition techniques which in theory should prove the basis for good design, but their success can be diminished by other factors: weak subject matter, poor technical skill, and so on. On the other hand, many well-known artists deliberately contravene the supposed 'rules' of composition to produce paintings of great interest and impact. An unusual and interesting composition will add to the success of the painting, but a poorly planned design will only detract from it, no matter how expert you are with technique.

Think carefully about your landscape and how its main shapes are going to be arranged on the paper. Ideally, there should be some interaction between the various shapes of the basic design, creating a sense of movement round the picture, and in most landscapes a feeling of depth. Avoid shapes which are all of similar size and form, and instead aim for contrast. Remember

73 (Above left)

74 (Above)

75 (Left)

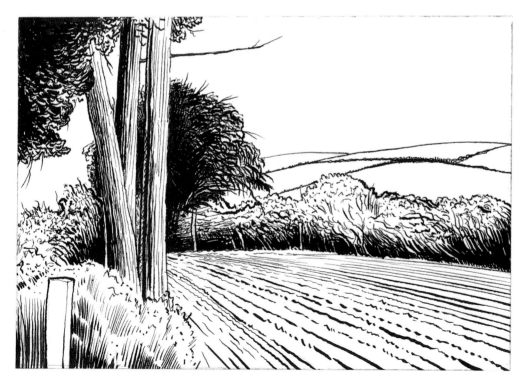

that composition is not only about the positive elements of the painting (the main shapes of the subject), but equally about the negative spaces (the gaps and background areas). Good composition is as much knowing what to leave out as it is deciding how to arrange what you put in. As always, we can learn much by studying the work of those better and more experienced than ourselves (see Chapter 7).

76 Some basic composition divisions.

a

b

c

d

e

f

g

h

Some compositions are ready-made, for example a view framed by the branches of a tree. Other ideas may need to be tried out in various ways before making a firm decision. A small card viewfinder (opposite) may help in selecting a particular section of landscape. Traditional landscapes are oblong, but think carefully about the proportions of your picture in relation to what you intend to paint. The painting does not have to fit a standard-size sheet of paper.

An important consideration in any landscape is the proportion of space devoted to land and sky. In an open, flat landscape, such as marshland, the sky might well dominate and thus take up most of the painted surface. In general, an asymmetrical composition works best and the division between land and sky should be unequal. Look at examples (a)–(h) in Figure 76. The typical landscape might have land/sky proportions similar to (a), but sometimes (b) works just as well. A 50/50 split is much more difficult, although it can be offset by other elements of the design so that the effect of dividing the picture in half is minimized. A 'Golden Section' proportion is shown in (c) and (d). This is a mathematical proportion of approximately 8:13 (or exactly 0.618:1), which was discovered by the great artists and scholars of the Renaissance. The harmonious and visually satisfying proportions of many pictures, whether designed by pure intuition or by formal calculation, seem to correspond with this ratio of division. In a landscape painting, the use of the Golden Section would divide a picture area so that roughly two-fifths of the way across there would be a tree or some other prominent feature. A vertical feature used in this way also helps to counterbalance the horizontal nature of the landscape. The basic divisions shown in (a) and (b) can also be based on the Golden Section.

Alternatively, the main stages of the painting might fit into a roughly diagonal shape as in (e), with the sky filling much of the remaining area. It is sometimes worth considering using the 'portrait' shape, as in (f), (g) and (h), if this suits your idea better.

Three alternative composition ideas for the same landscape are shown in Figures 77–79. Refer to 'Experimenting with Composition' on page 63 and see if you agree with my comments on these.

I prefer to develop my paintings from preliminary sketches or some form of research work. This gives me the opportunity to plan the composition quite carefully before I begin the actual painting. Even if you

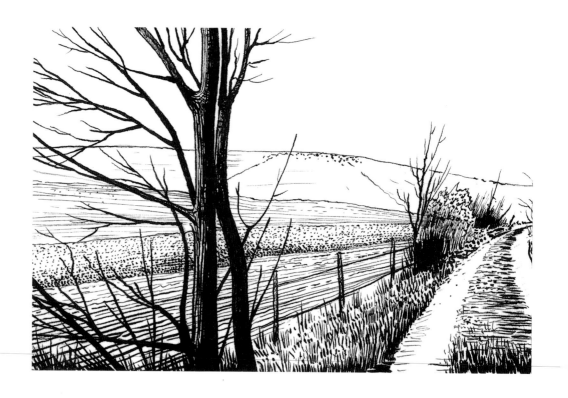

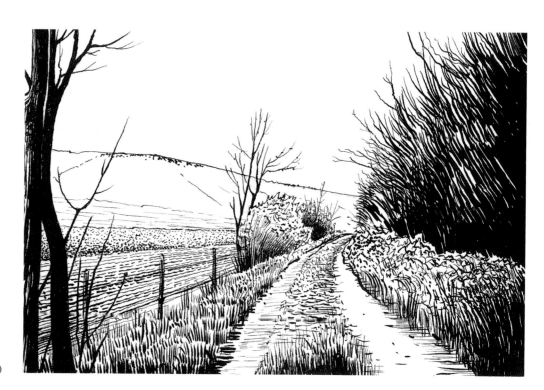

77 (Above)

78 (Right)

79 (Far right)

like painting directly from the landscape, it is worth making a few quick pencil sketches first just to establish the foundations of the composition. Make two or three simple line drawings to help you work out the main shapes. Remember it is your idea, your composition, and an element of interpretation is always a good thing. Although you may well want to be as faithful as possible to Nature, like Constable you can leave things out or even move them. As a general rule, use a foreground shape with some detail to contrast against broader areas of landscape beyond. Figures, animals, trees and houses are useful to establish relative scale and distance.

Not all landscapes are designed to suit the sort of divisions and proportions described above. Sometimes the composition arrangement is more subtle. Always look for some structure to your painting: this can be achieved by using lines and other devices to help emphasize direction and movement, at the same time linking together the various shapes of the composition. Try to design the painting so that the viewer's eye is led to a focal point (a highlight or feature of some kind), and so that his or her attention

is kept within the bounds of the picture. Avoid strong lines and bands of colour which simply disappear off the edge of the paper.

A landscape formation like the one in Figure 83 may appear to have no obvious structure. Also, the way the artist has composed the painting means that there is very little sky area. In most landscape paintings, the sky forms a useful and exciting backdrop to the landscape, creating contrast both in colour and character, and helping to suggest distance. So it is difficult to manage without some sky. Close analysis of this painting shows it to have a very diagonal flavour. A composition sketch (Figure 82) shows that the main lines of axis, the foundation lines for the design (the bold, straight lines in the illustration), run in a diagonal direction. The top edge of the quarry roughly divides the painting diagonally in two. No division in a landscape should, of course, be rigid, but broken and slightly meandering. Notice also that, although the main direction in this painting runs diagonally from right to left, shorter lines going in the opposite direction help to counter this and direct our interest towards the centre. Try a similar analysis of your own composition sketches.

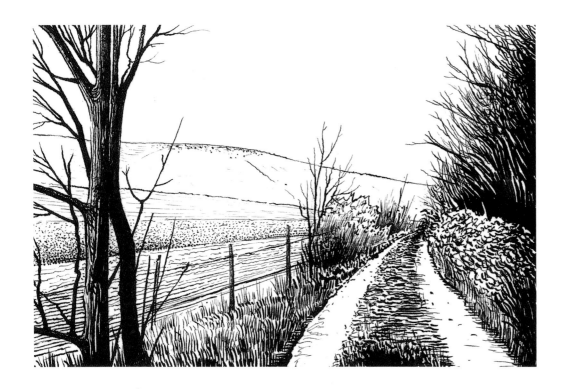

80 *Still Waters*. Watercolour

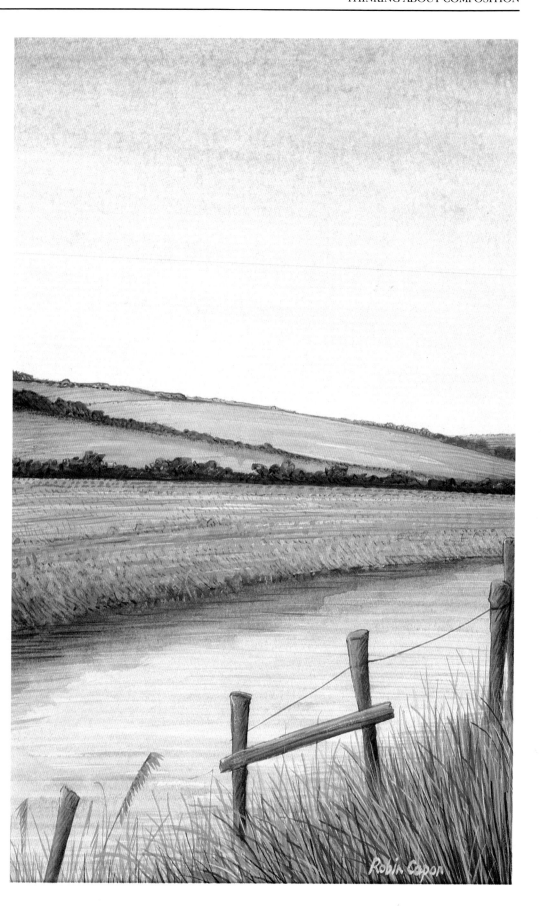

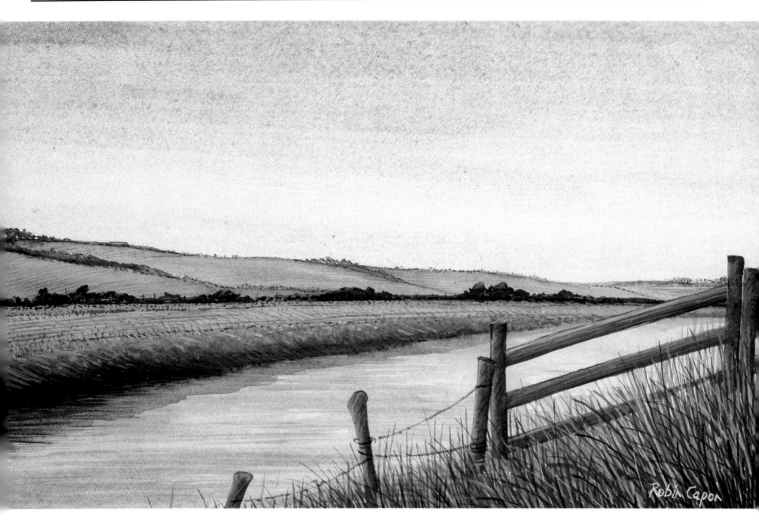

81 *Still Waters*. Watercolour

EXPERIMENTING WITH COMPOSITION

Many landscape paintings are technically very sound, but because the composition lacks any real visual 'punch' the results are dull. As well as careful planning and preliminary composition sketches to help you clarify ideas, don't be afraid to try out some unusual viewpoints or to experiment with the overall picture shape. Sometimes a particular subject, or a single spot in the landscape, can provide a whole range of possible paintings just by slightly altering the viewpoint. The paintings in Figures 80 and 81 are done from the same spot, but notice what a difference it makes when you use the paper the other way up. Don't distort an idea merely to fill a standard-size sheet of paper – cut the paper to suit the idea!

Look again at the three alternative composition drawings shown on pages 60–61. As you can see, they are all done from roughly the same place. Each has some merit, though I would consider Figure 79 to be the best. In Figure 77, the large trees almost divide the design in half and the track leads the eye straight out of the picture on the right-hand side. In Figure 78, the left-hand trees are uncomfortably near the edge and the right-hand group forms a bulky and rather dominant mass.

There is plenty to think about with composition but, like so many aspects of painting, do not get weighed down by the theory and let it destroy the momentum of your work. Remember the points I have raised, but rely also on your own intuition and feeling for what looks right.

82 Composition sketch for figure 83.

83 *Judith Ackland painting 'The Shadow Tree at the Quarry Edge', 1943* by Mary Stella Edwards. Watercolour. (Burton Art Gallery, Bideford)

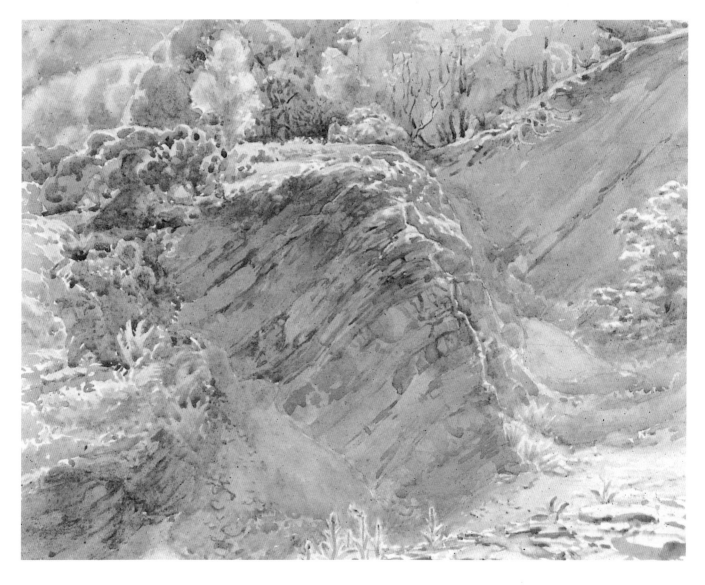

Creating Mood and Atmosphere

● Light and dark ● Depth and space ●
● Skies ● Water and reflections ●
● Features in landscape ● Weather effects ●

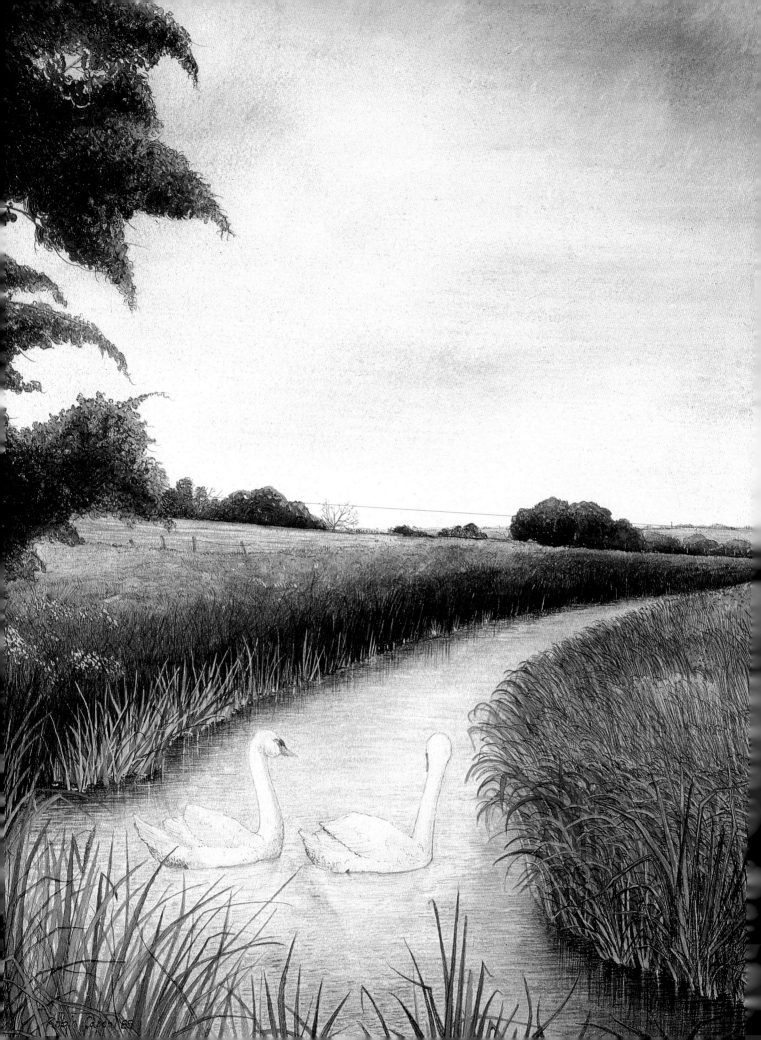

5

Creating Mood and Atmosphere

THROUGHOUT THIS BOOK I have stressed the scope and versatility of watercolour. It is the medium of delicate washes, suggestion and impression, just as it is of detailed and highly resolved painting. When Van Gogh first used watercolour, he wrote: 'What a wonderful medium to render atmosphere and distance! The figure seems to breathe the air that surrounds it!' Its versatility makes it ideal for painting the variety and feel of landscape, with all its changing moods.

The landscape artist must be persevering and resilient. It will not take you long to realize that your subject matter can be fickle, and that expectation and enthusiasm can easily be quenched by a sudden downpour! Sky, light, weather and season all play their part in creating the character and mood of the landscape. These intangible qualities are something we have to strive to reflect in our paintings if they are to succeed. No subject profits from mere mechanical interpretation, least of all landscape. You must aim to capture the spirit of the scene with your own personality, as well as with the wise selection of colours and techniques. As your painting progresses, begin to think about the character of the landscape in front of you; how light and dark, depth and space, weather effects and different features all help in creating a particular mood and atmosphere.

Compare the very different moods achieved in Figures 84 and 85. Figure 84 has an almost impressionist touch in places; there is a great feeling of light and space, and the mood is jolly. In contrast, in Figure 85 the darkness of the wood accentuates the freshness of the spring wheatfields.

LIGHT AND DARK

Not all paintings need the stark contrast between light and dark shown in Figure 85, but the effect of light, from highlights to shadows, is an important element of any work. The way light and shade is used can be vital in establishing a certain mood in a painting. A stormy winter's day needs dark colours, heavy shadows and some aggression in the technique, as in Figure 9 (page 14). On the other hand, hardly any shadows are used to convey the rich greens of the summer landscape in Figure 115 (page 91). Bear in mind the overall distribution of light when you first look at a landscape. Half close your eyes to help accentuate light and dark, and make you more aware of them – usually in painting you will need to exaggerate what you see. Consider where the source of light is and how this may affect any shadows. Think about highlights and whether these need to be left as white paper. Often the lightest part of sky is on the horizon.

DEPTH AND SPACE

Although a landscape painting could be based on part of your back garden or a similar fairly confined view, usually the area covered is more extensive. In condensing acres of landscape onto a small sheet of paper, you may encounter some problems. What is seen often has to be simplified, yet at the same time the original sense of depth and space has to be maintained. Confronted with this problem of a dramatic reduction in scale, it is easy to lose sight of those features and elements in the landscape that help to convey the feeling of distance. As you plan your work, yet another consideration is therefore how to achieve a sense of depth. Who said painting was easy and relaxing?

Many artists employ a device like perspective to help them create the illusion of depth in their pictures, but this is seldom possible for the landscape artist. There are very few straight lines in Nature, nor should we want there to be, for they would give a rigidity which is

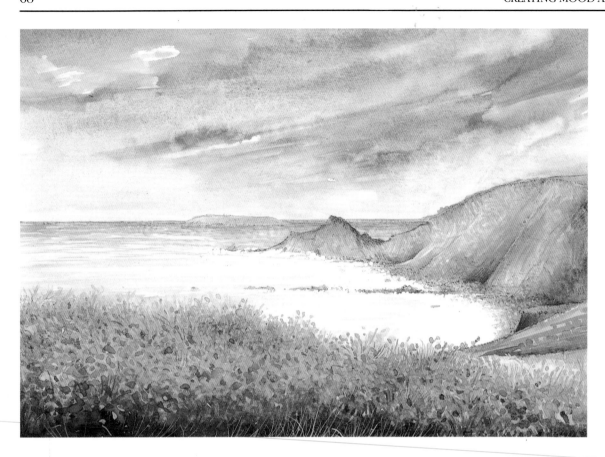

84 *Rocks at Hartland.* Watercolour and gouache on stretched cartridge paper.

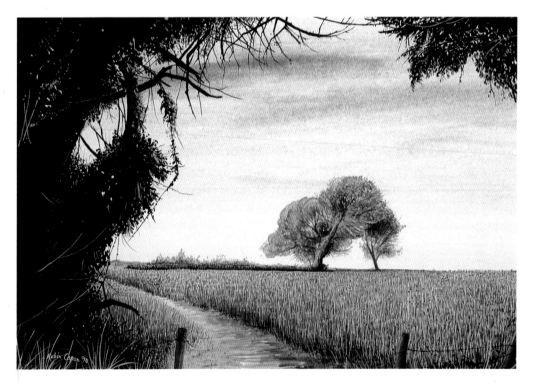

85 *Out of the Wood.* Watercolour and gouache on stretched cartridge paper.

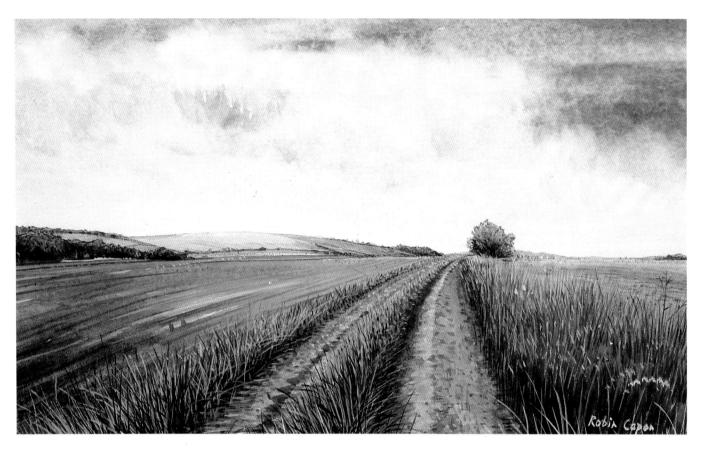

86 *The South Downs Way.* Watercolour and gouache on
stretched cartridge paper.

totally alien to the natural, flowing lines of landscape.
However, a view may include a feature, such as a
building or fence, which has straight lines. Try to use
such features at an angle in the painting, so that the
direction and distortion through perspective help lead
the eye back to the distance. Although not absolutely
straight, the influence of perspective on something
like a grassy track (Figure 86) can create a dramatic
sense of distance in a relatively small space.

Another way of creating an impression of depth is to
contrast a close-up study of a landscape feature, such
as a tree, with a vague impression of hills and general
landscape in the distance. This visual play between
large foreground shapes and small background ones
gives a great feeling of space, especially if you
exaggerate it slightly, as in Figure 87. As in any
painting, the relationship between the relative size and
scale of things is important.

You can also use colour and detail to help suggest
depth. The combination of distance with the effects of
atmosphere causes colours in the far landscape to
become weaker and cooler, making distant hills look
blue – an effect known as aerial perspective. These
low-key background colours can be contrasted with
warmer and stronger colours in the foreground.
Remember, too, that the sky is not a vertical wall of
colour but that it also recedes to the horizon.
Theoretically, therefore, the top edge of your painting,
representing the nearest part of the sky, should be a
stronger colour. The nearer parts of your painting
demand more positive colour and will also be the
areas that need the most detailed treatment. If you
cannot use any obvious foreground feature to help you
establish a contrast of scale, perhaps you can make use
of variations of colour and detail, as shown in Figures
86 and 87.

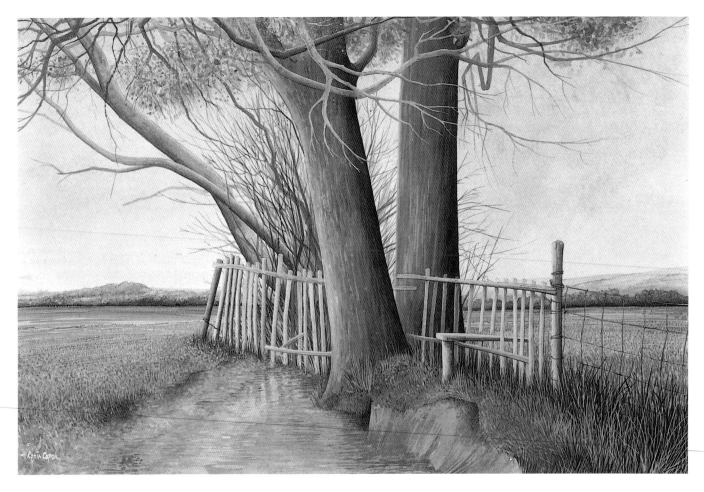

87 *Autumn Beeches, Hunton*. Watercolour.

SKIES

I have already stressed the importance of the sky area in relation to the overall composition of the painting. In addition, it determines the quality and distribution of light throughout the work and influences the colour key. Because of its transient nature, a sky is an ideal subject for watercolour. The character of the sky establishes a mood for the whole painting and many landscape paintings are predominently skyscapes with just a trace of land.

Most artists evolve a number of sky techniques of their own from a variety of basic methods. I advise the beginner to experiment with all of the effects described and illustrated in the next few pages. A sky usually needs to be painted quickly so you will want to use a technique that you are confident about, but get to know a range of methods. You may find, like me, that you want to combine several techniques to build up the right sort of sky for your painting.

Experiment first with some colour mixing. Like anything else, a sky colour seldom comes straight from the tube! Mix washes of cobalt, ultramarine and cerulean blue. Test them out on some spare paper and then try mixing and modifying these colours with the addition of a little burnt umber or Payne's grey. As always, the type of paper will affect the result. I suggest you test your initial ideas on heavy-quality cartridge paper or 120 lb (255 gsm) watercolour paper. Stretch the paper before use (see page 87).

For an effect like the one shown in Figure 88, use dampened paper and lightly touch in two or three tones of colour wash from a heavily loaded brush. Work with the paper at a slight angle so that the tones run slightly and fuse into each other. Make use of some white areas. Acting quickly, blot parts of the wash with

tissue paper to give the suggestion of cloud formations.

If you want a stronger effect with more cloud texture, you can work over a basic dry wash with thicker subsequent washes, perhaps mixed with white gouache. This is the method used in Figure 89. Use a dry brush technique to create light whiffs of cloud and re-wet as necessary to blend the edges together. Be careful not to overwork the paper or the surface will start to break up.

Try a wet-in-wet approach to get the sort of soft-edged cloud formations shown in Figure 90.

Many skies have very subtle blends of colour with soft-edged cloud formations and these characteristics are best achieved by using a wet technique. Try out the four methods shown in Figures 91–94 and see if you can invent some variations.

A wet-in-wet approach was used in Figure 91. Work with the paper set at a slight angle and wet the entire sky area, using a wide, flat brush and clean water.

88

89

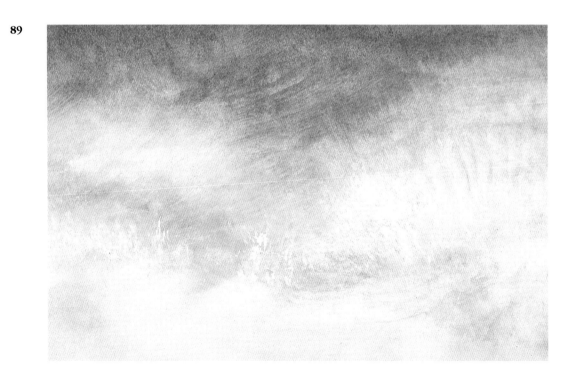

Quickly lay in the colours you want, allowing them to diffuse into the surrounding colour or space. You will notice that I have used quite positive horizontal brush strokes, but don't be afraid to try other directions and effects. While the paint is still wet, you can add a little more colour to some areas to suggest the density of clouds.

An effect like the one shown in Figure 92 is made by applying a restricted wash over dry paper. Again, use a flat wash brush but do not overload it; this will allow you to pull the paint out in a fairly dry state to make some lighter tones and softer edges. Build up the strength of colour in some parts by adding to the still wet wash; contrast this with light areas left as white paper.

In Figure 93 I used a number of brushwork effects worked wet-in-wet. Try stippling into wet wash with a dry stiff-hair brush, or lifting the wash from some areas with a brush, tissue or rag (see page 26). If you want to create particular cloud shapes, you can mask them out with masking fluid before the wash is applied, as in Figure 94. Use the masking fluid in the way described on pages 37 and 38. After the dried solution has been removed from the paper, you may wish to work

subsequent washes over parts of the cloud shapes to reduce their intensity and give them some form.

As you gain some confidence in handling sky effects, it is a good idea to experiment with a wider range of colour. Like water, the sky will reflect colour from the landscape, a fact which can be exaggerated to produce greater harmony between sky and land. Be adventurous and introduce a little green to the underside of clouds, or try a sunset! Alternatively, you can start with a colour wash (for example, pale yellow ochre) which you can work over, allowing the wash to show through in some places to give a glow to the clouds. Build up a collection of different types of sky, cloud formations and so on which you can refer to. Go out sometimes with the express intention of making sky studies.

Where possible, I like to use the actual sky seen with the particular landscape I am interested in painting. I confess that occasionally I need to invent a sky, especially if the painting needs livening up a bit. But be careful to match the sky to the landscape; this is why the original is usually best. However, it is interesting to note that a number of famous artists, Turner included, used imaginary skies in many of their watercolours.

90 *Wind Westerly, Showers Developing* by John Palmer. Watercolour. (Burton Art Gallery, Bideford)

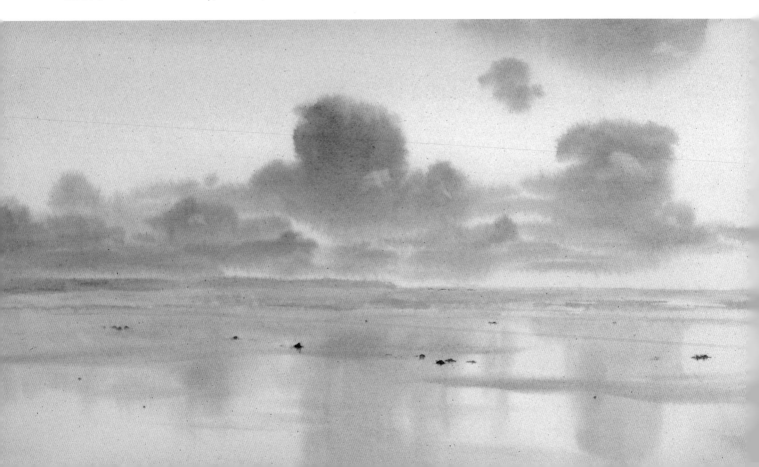

91

92

93

94

WATER AND REFLECTIONS

Water is another aspect of subject matter which can greatly influence the feeling and atmosphere of a painting. It mirrors the surrounding sky and landscape, and will emphasize the general mood. Even for the experienced artist, water is not an easy thing to paint. It can be turbulent or placid, shimmering with light or dulled with reflected shadow, frozen or full of summer colour.

For the beginner, it is essential to get out on location and make some first-hand studies. Start with some sketchbook drawings in pencil and pastel. Make some very careful observations to really get to know something about the changeable surface textures of water, and how its character depends on the surrounding forms and colours. Use these drawings as a means of enquiry, for looking and noticing, rather than worrying about their success. Add written observations if you wish. Any additional reference

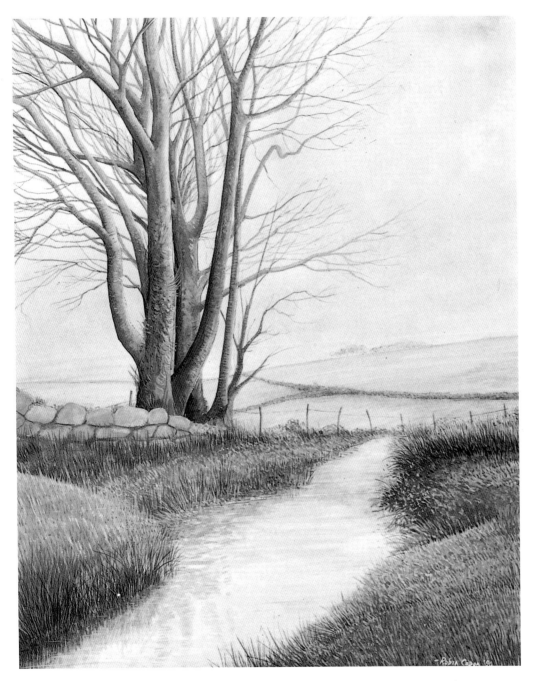

95 *Beeches and Stream, Dartmoor.* Watercolour.

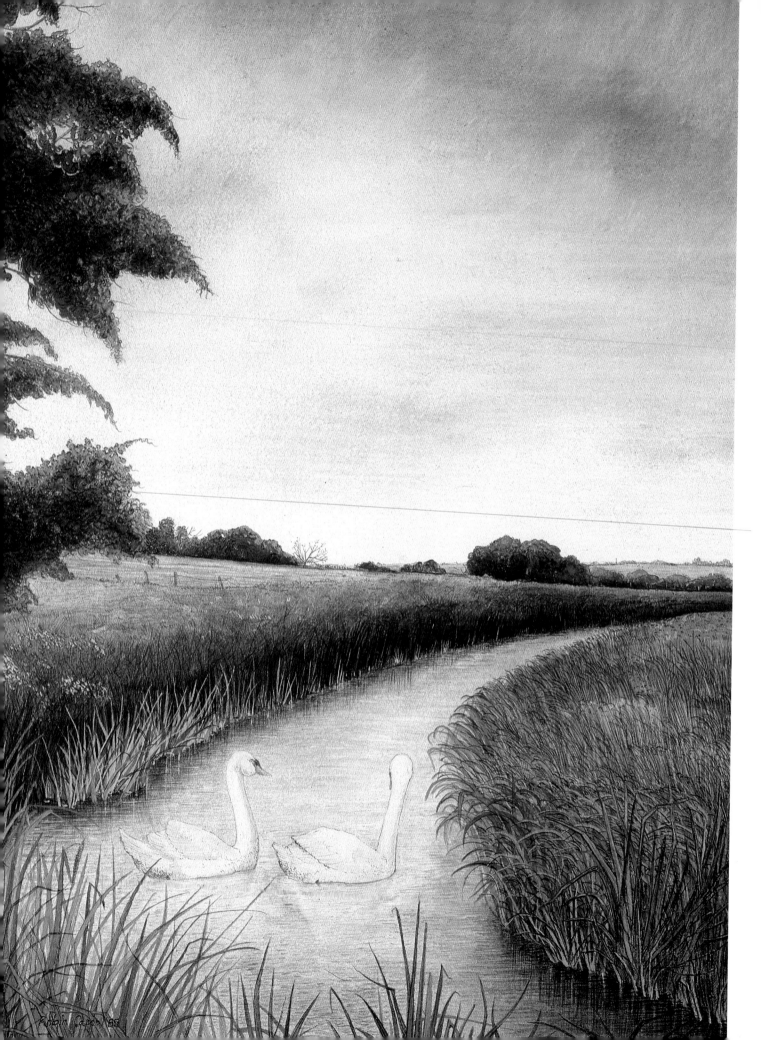

96 *Chislet Marshes*. Watercolour with pastel and coloured pencil.

material is useful when you are confronted with a difficult watery bit of landscape later. Now try some quick wash studies in watercolour. The more you learn about painting water, the more you will realize it has to be painted quickly. Usually the transparent and reflective qualities of water mean that it is best painted with a wet wash or wet-in-wet technique. Notice what colours are reflected in its surface; like the sky above, water picks up a lot of colour from the landscape.

Essentially, beware of overworking a water area. My preference is to work into a wet, weak wash (Figure 95). Select a basic wash which mostly reflects the sky colour above. Leave highlights as white paper. Use a brush size which suits the character of the water: work with a no. 6 or no. 8 pointed sable if the surface is rippled, and with a 20 mm flat if it is fast-flowing and turbulent. While the paint is still wet, add other colours and reflections. Pay great heed to how colour is reflected from adjacent banks and other landscape forms, and consider how this can be used to create harmony in your painting.

Watery effects can also be achieved by various mixed media methods, again starting from a basic thin wash. In Figure 96 I used pastel and coloured pencils over the underlying wash.

FEATURES IN LANDSCAPE

I am a great devotee of pure landscape, by which I mean the kind of landscape which is off the beaten track, well away from the scarring and so-called 'civilizing' influence of man. I believe such landscapes are an exciting and challenging subject in their own right and do not need the intrusion of figures, buildings and other reminders of the outside world to make them succeed as paintings. However, I admit that a feature such as a farm building can create a useful point of interest in a painting, and provide contrast both in subject matter and scale. A storm-stricken oak, a grazing ewe, a rocky outcrop or a collapsing linney will all help to liven up the composition and at the same time perhaps give a subtle human touch.

Aim to use a feature in such a way that it contributes to the general landscape setting and its mood. Some

97 (Below left)

98 (Below right)

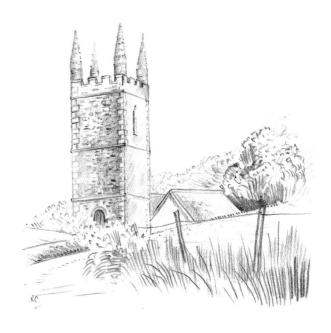

modern pre-fabricated farm buildings are simply landscape blight. Far more visually exciting and naturally suited are barns or shelters built of local stone or timber, preferably in a state of slight disrepair and camouflaged with a creeping evergreen! Farm gates, fences and other man-made contributions to the landscape are far less obtrusive if they are weathered and broken. Other introduced features, like a friendly sheep or a craggy quarry face, seem more a part of the landscape. Trees, whether raped by wind or graceful in shimmering verdant foliage, are the rightful actors on the landscape stage. Used as a feature in a painting, the individual character of a tree will set the mood of the whole scene.

Although it is possible, sometimes necessary, to introduce a feature into a landscape painting, it usually works best if you use the feature in its actual setting. Sometimes you come across a marvellous old farm building or piece of rusty machinery tucked away in a dip or the middle of a copse, so these may need a new setting. Country rambles can reveal a wealth of interesting structures and natural forms to use as features in a painting – another opportunity to use your sketchbook. Build up a collection of reference drawings. Detailed studies like those shown in Figures 97 and 98 can be a great help when you are working back in the studio, and so too can a location painting, like the one in Figure 99. Look at the other features I have illustrated on the following pages. They make wonderful and enjoyable sketchbook studies and can be done in ink and wash, or pencil and wash, as in Figures 100–103.

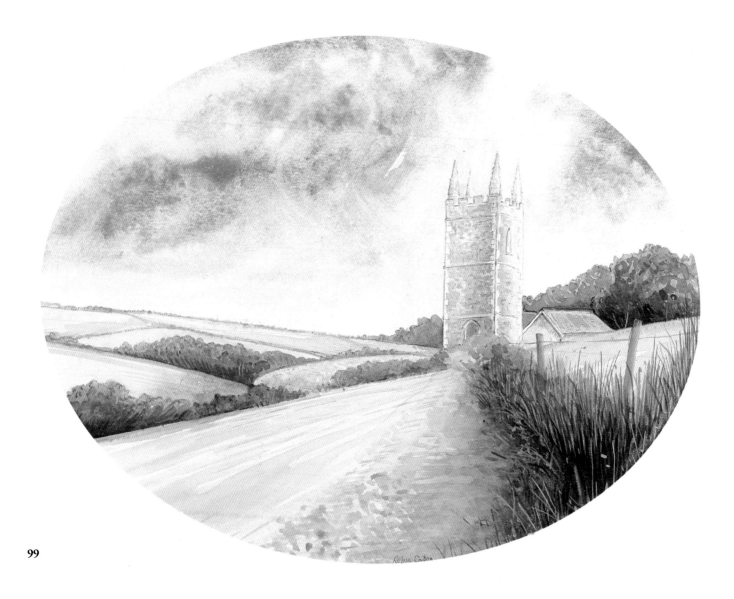

99

100

101

102

103

A detailed and highly resolved foreground feature will make a good counterbalance to broad sweeps of landscape beyond. You can use it to introduce a positive splash of colour, as in Figure 49 (page 32); to give a contrasting texture, as in Figures 43 (page 30) and 115 (page 91); or to suggest distance by virtue of scale, as in Figure 87 (page 70).

WEATHER EFFECTS

A landscape artist living in the wilds of north Devon, I am very aware of the weather! I know how it can affect my mood, and that it plays a dominant role in establishing the character of the landscape. If I liken landscape to a stage, then the weather is the lighting and stage effects. As in the theatre these enhance and dramatize what we see, so too with the effect of weather on our surroundings. I can appreciate why some artists become fascinated by a single piece of landscape. It is never quite the same, because changes of light and season mean that subtle and even very obvious differences evolve from one day to the next.

Many of us understandably favour painting outside on a calm, warm day in summer rather than a chilly, breezy day in early December. But, even if weather-worn and weary, it is very satisfying to have been out in adverse conditions to capture a new mood and atmosphere. So try not just to be a warm-day landscape painter – face the elements and be prepared to suffer for your art. The sky isn't always a thin veil of blue! Once again, such forays are probably more suited to sketchbook work than to attempting a resolved painting. There are of course many physical difficulties, not to mention sheer discomfort, when painting in wild weather. Use charcoal, pastel and perhaps line and wash techniques which can be manipulated quickly to give an immediate impression of a particular effect. Add the date to your drawing and some written descriptive notes, and perhaps take a photograph as extra reference.

104 *Common Moor, North Devon.* Watercolour with gouache.

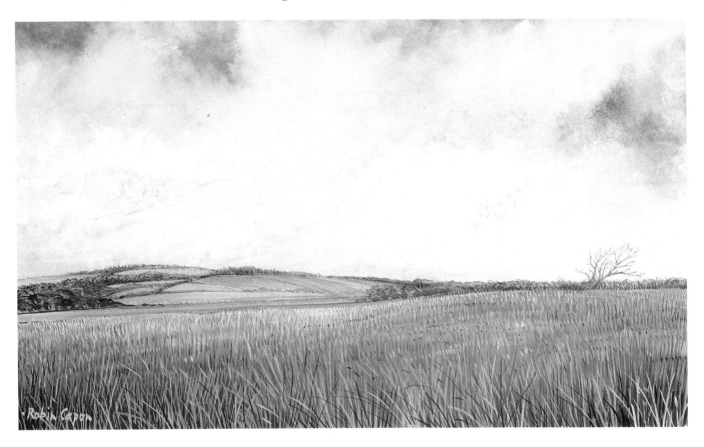

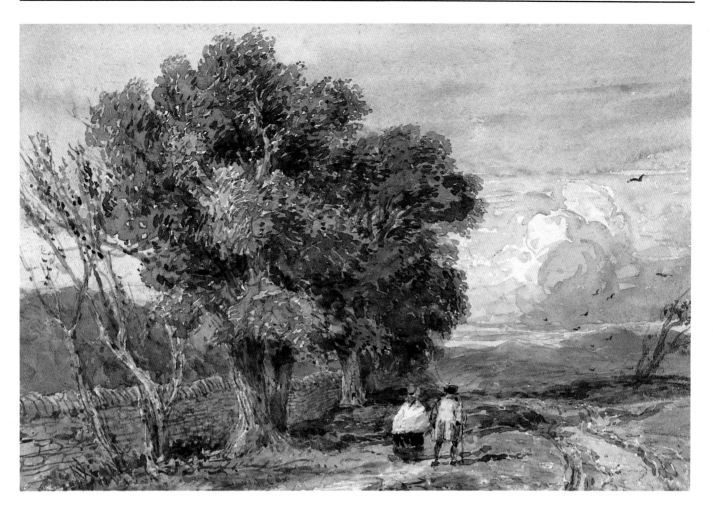

105 *A Windy Day* by David Cox. Watercolour. (Williamson Art Gallery and Museum, Metropolitan Borough of Wirral)

Painting is feeling as well as observation. Being in the landscape, soaking up the atmosphere (sometimes literally!) and becoming absorbed with what you see can be as important as actually sitting down to make a drawing. You need to sense the spirit of the place as well as making visual records and reminders. Try to recapture this feeling when you start to turn your sketches into paintings back in the studio. Get into the mood of the work and concentrate on techniques which will help you fully express that mood.

Although the sky is a good indicator of weather mood, it is not the only aspect of a painting that will convey the consequence and influence of a particular kind of weather. For example, a sunny, blue sky often accompanies an early, frosty morning. What other features of the landscape help to suggest a weather effect? Our principal actors, the trees, always put on a good performance. Look at the scurrying clouds and wind-bent tree in my open moorland painting (Figure 104), and the wonderful handling of watercolour to suggest a windy day in David Cox's painting (Figure 105). Refer also to other colour illustrations in this book, especially Chapter 7, to see how different artists have interpreted the moods of weather.

Developing an Idea

● Research ● Selecting and preparing the paper ●
● Working though stages ●

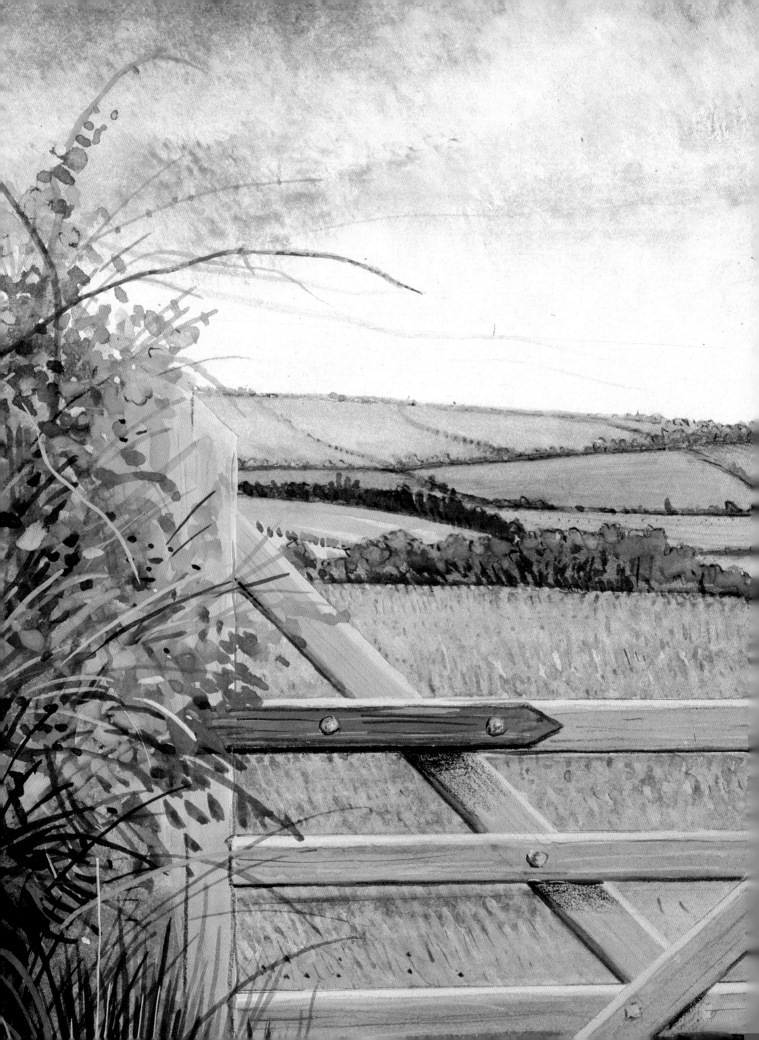

6

Developing an Idea

A S YOU BECOME more experienced with watercolour techniques and more familiar with landscape as a subject matter, you will begin to develop an individual philosophy and a particular working practice. As well as providing you with factual information, my aim has been to recommend ideas which I think will help you in your quest to paint landscapes in watercolour, and to suggest other avenues to explore. I believe that a good general grounding, which confronts all attitudes and all techniques, is vital before a painter can see how to progress in a more individual way. If you try out all the approaches and ideas I have suggested, you will have a broad experience from which to proceed. Some techniques will work better for you than others, and you will find an empathy with certain philosophies while some you will utterly reject. Painting a landscape demands a very personal response.

The precise way you set about making a landscape painting is for you to choose in the light of experience. Some artists need to work *en plein air* so that they can directly absorb the atmosphere and feeling of the landscape. Others prefer to work in the studio from previously researched material. You will probably have noticed that in general I recommend the latter approach. For the beginner, I think painting outside can present many problems and can result in disappointment. My advice is to save the business of painting good, well-finished landscapes for the studio. Here you can work on them unhindered and with full studio facilities, so that you have the opportunity of doing the best possible job. I must stress, however, that there is no substitute for working directly from the landscape. Get out and about as much as you can and collect plenty of reference to help you back in the studio. The process of working described in the next few pages, although written with studio work in mind, equally applies to paintings done on the spot.

RESEARCH

Good planning is a sound investment because it will ensure that an unforeseen problem does not spoil your aspirations. However, once an idea gains momentum, there is something to be said for getting on with it, capitalizing on enthusiasm and inspiration. So don't do so much preliminary planning that you are tired of the idea before you even get round to mixing a wash! The usual plan would be to spend one day outside doing preliminary research in the form of sketches, studies and colour work, followed by some consideration of the choice and preparation of paper, and finally the various stages of painting.

Get the most out of your time outside doing location drawings. Try to provide yourself with alternatives to your main idea. For my *Gateway View* idea (see pages 88–91), I made drawings of various types of farm gate and the views beyond. Two of these drawings are shown in Figures 106 and 107. Consider the sort of visual reference which is most going to help you when it comes to the final painting. Bear in mind the range of techniques that you can choose from for working outside, and the various approaches discussed in Chapters 3 and 4 on ideas and composition.

SELECTING AND PREPARING THE PAPER

With most paintings, it is vital to choose the correct type of paper if a particular mood or effect is to be successfully achieved. If you are not sure about a particular paper, use a small piece to test out wash or other techniques. Refer back to page 15 and to Figures 11, 35, 44, 55, 68 and 115, which show a variety of techniques using different types of paper. You may well get used to a favourite paper, but be prepared to experiment.

106

107

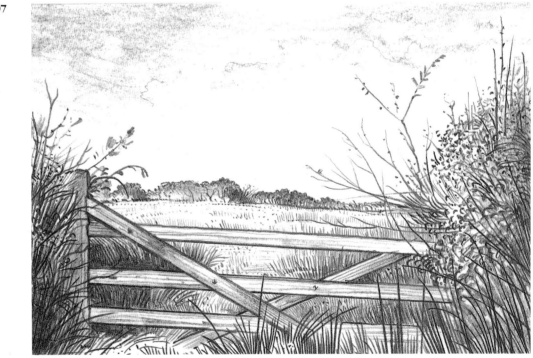

All except the very heaviest-quality papers will require stretching or taping down in some way before you start painting. If you are using a method which involves just light tints of colour or dry brush effects, it will only be necessary to fix the paper to a drawing board with some masking tape or gummed tape. Remember to select a sheet of paper which is larger than the painting area you want; allow for the overlap of the tape, plus a margin for the mount (see Figure 108 and page 105).

For wet-in-wet, wash techniques, spraying and any other method which is likely to wet the paper, you must 'stretch' the paper first. Stretching will ensure that the paper dries flat, otherwise it is likely to 'cockle', or distort, after being wetted. The process is shown in Figure 109. First, soak the paper in clean water (a). Make sure both sides are wetted thoroughly by dipping it in a tray of water, placing it under a tap or applying water with a clean sponge. Heavier-quality paper should be left for a minute or two to ensure that it absorbs the water. Place the wet sheet of paper flat on a drawing board (b). Work quickly before the edges begin to wrinkle. Next apply wetted strips of 50 mm gummed tape to all the edges. The strips should be long enough to overlap and be folded under at the corners (c). On large sheets of paper, use two strips of tape down each side. Dab with a wet sponge to persuade the strip to stick to the paper. Let the tape follow the contours of the edge; don't crease the paper. Make sure that the corners are neat and secure (d). Leave the paper flat to dry out thoroughly. Be patient; this seemingly soggy piece of paper will end up completely flat!

Some paintings may need treating with an initial stain or wash of colour. This can be quickly applied with a sponge (Figure 114) or large, flat, soft-hair brush. Paintings which involve resist techniques or masking fluid may need applications of wax, fluid, etc. at this stage as a basic preparation.

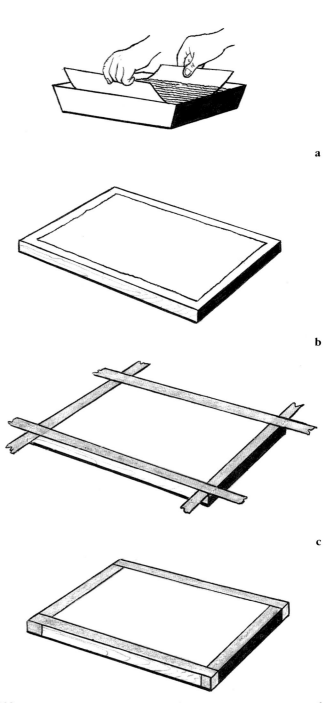

a

b

c

108

109

d

110

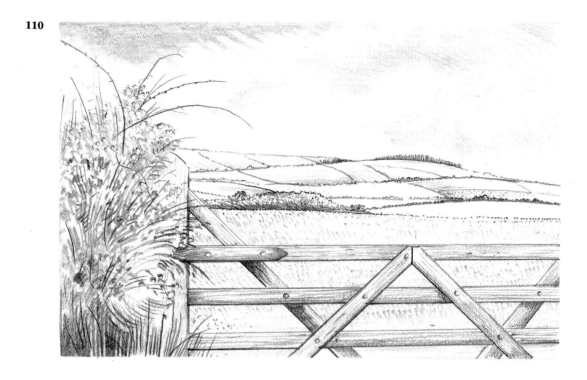

111

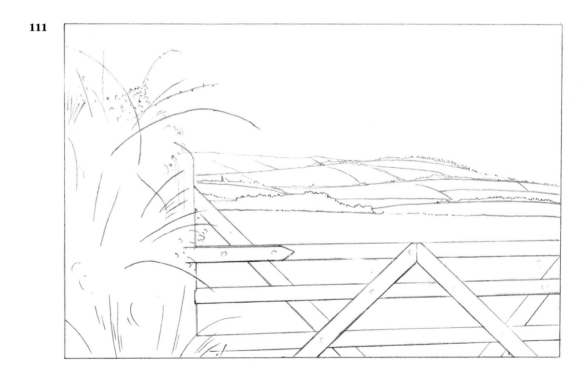

112

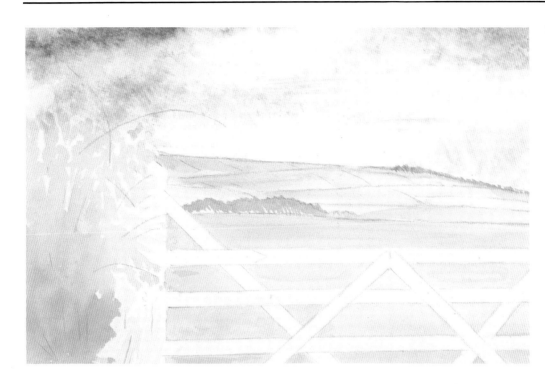

113

114

WORKING THROUGH STAGES

From your collection of research work, you will need to deliberate over the best idea to use and how to shape it into an exciting composition. You may decide to combine parts of various drawings done outside or you may have done a very careful study, like the one in Figure 110, which shows exactly the image you want to convert into a final painting.

Spend some time thinking about what your aims are for the painting. As well as the obvious selection and preparation of paper, think about the size and shape of the work, the colour key, and the mood and particular effects you want to convey.

On the prepared watercolour paper, lightly sketch in the main shapes of the composition with a soft pencil. Keep this pencil drawing faint and to the absolute minimum. Do no more than I have shown in Figure 111. Some artists, myself included, leave out this stage of working altogether, preferring to go straight in with a series of basic washes. However, if you lack the confidence to plan out the work directly with a brush, then the minimum of drawing will help. But remember that any drawing must be unobtrusive, and capable of being lost as subsequent washes are added. You may want to enlarge a carefully planned preliminary sketch accurately onto a larger sheet of painting paper. In this case, use the squaring-up method described on page 48. Take heed of the advice

not to make any lines too permanent, and be careful not to damage the textured surface of the watercolour paper if any lines have to be erased.

Next, prepare for the painting stages of the work. Decide on your palette, or range of colours, and put out quantities of colour ready to use. For Figure 112, I used a palette of cobalt, Hooker's green deep, sap green, yellow ochre, lemon yellow, burnt sienna and burnt umber. In addition, I used some Designers' White Gouache to help with the particular sky effect I wanted. I chose to demonstrate this particular painting because it incorporates several of the techniques covered in earlier sections of this book.

Keep your approach simple. Start with broad washes for the sky and general background areas. You will notice that I have used only four different colour washes, simply varying the strength of the two green washes in order to establish contrast where necessary. Apply the washes with the largest brush you feel confident with. Notice that I have left the gate as white paper. Rather than paint round such a shape, as I have done, you could use masking fluid (see page 37).

Proceed to a series of stronger, more controlled washes to add middle tones of colour, and begin to establish different forms, lighting contrasts and surface effects. It is usually best to work into the sky while the preliminary wash is still wet, and to complete the sky area at this stage. Because of the bulky cloud effects of my sky, I chose to use body colour in the form of white

gouache; this also allowed me to work into the sky at any stage with a wet brush or further applications of colour. In the next stage of this painting (Figure 113), I added a general wash to the gate. Had I used masking fluid, I would recommend leaving all the work on the gate to the very end.

In the last stage of the painting (Figure 115), I worked over the whole area as necessary to finalize the detail. This stage of working obviously depends on the methods you have chosen to adopt earlier. For example, areas being developed as wet-in-wet may need some speedy work to complete them. Other parts, like the gate and hedge in the foreground of my painting, may need quite a lot of fine, superimposed dry brush work. Start from the top and work down the painting. Add strengths of colour and final details, and define edges where necessary. Bear in mind the need for contrast and exaggeration to get across a sense of depth or a particular mood. Don't be afraid to use high-key colour, as I have done, if you think the subject needs it. Finally, have a long critical look at the whole picture and see if any small alterations should be made.

115 *Gateway View near Melbury, North Devon.* Watercolour with gouache on 140 lb (300 gsm) stretched Cotman paper.

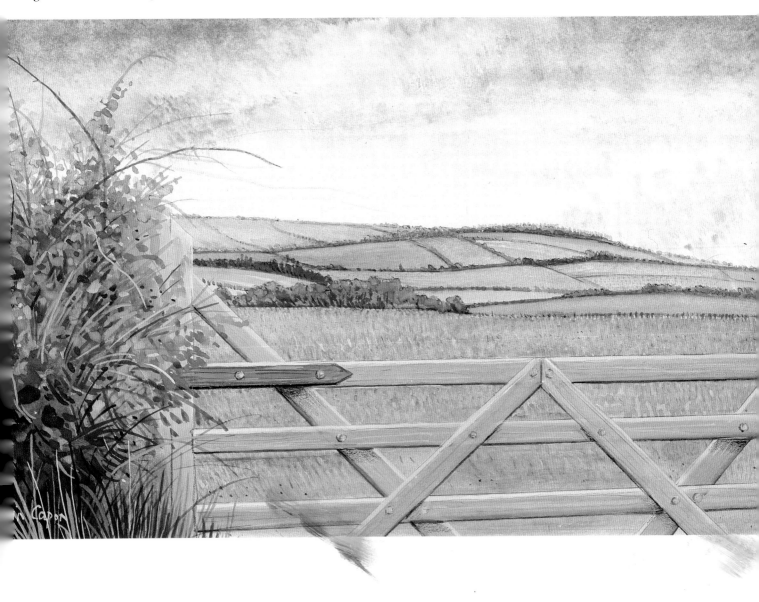

Gallery

● Eight famous landscape painters ●

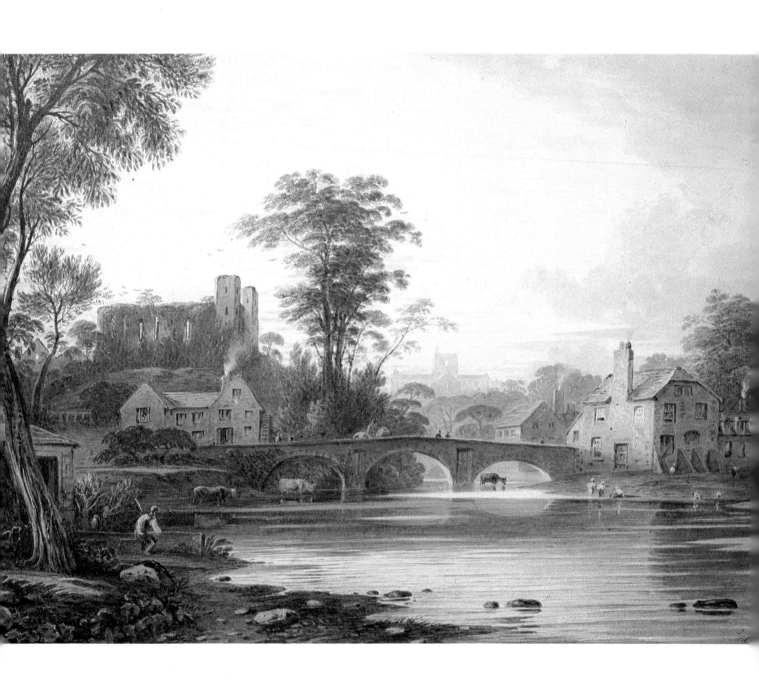

7

Gallery

WITH ITS ABILITY to be used speedily and delicately to capture the transient effects in Nature, watercolour proved the ideal medium for the Romantic painters of the late eighteenth and early nineteenth centuries. Here are examples of the work of eight of the great artists of that period, each demonstrating a rather different approach and technique. These paintings will help you appreciate the wonderful potential of the watercolour medium, and I hope will leave you inspired and eager to start on your own paintings.

I hasten to add that not all the best watercolours were painted two hundred years ago! Visit museums, art galleries, local exhibitions, libraries and bookshops to find other examples. See also Further Reading, page 111.

David Cox (1783–1859) was a theatre scene painter before he was able to rely on painting for an income. The broad treatment required for theatre scenery provided a good training for conversion to loose watercolour techniques, as in Figure 116. He loved the rugged scenery of North Wales and was particularly fond of storm and wind to add drama to his work. Note the freedom of brushwork, the limited use of colour and the effects of light and dark. See also his *Windy Day* painting on page 82.

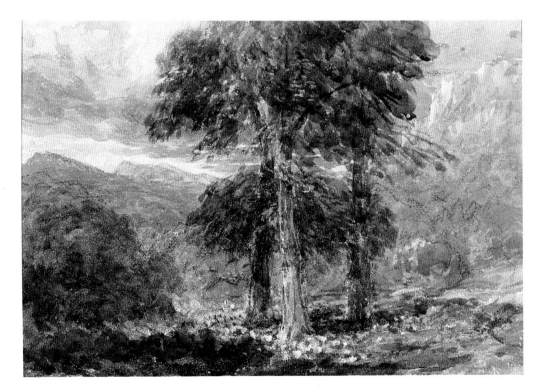

116 *Harvesting* by David Cox. Watercolour. (Williamson Art Gallery and Museum, Metropolitan Borough of Wirral)

Alexander Cozens (1717–86) is perhaps rather unjustly remembered for his 'blottesque' landscapes more than his beautifully atmospheric and solitary scenes (Figure 117). He was fond of experimenting and was the inventor of the 'blot' method, haphazard blots or dashes thrown on the paper which he then developed into an imaginary landscape. For this, he used Indian ink as well as watercolour. An occasional experiment like this is a good idea; it is fun, and helps maintain spontaneity in your work. Try making your own blot on the landscape, perhaps wet-in-wet!

Notice how the artist has distorted light and dark, using shadows not only to contrast and enhance colour but also as a composition device. See how the composition revolves around the central triangle of the lake. The eye is carried across the foreground, up the tree and across the dark clouds at the top. The glassy water effect is set against the broad treatment of the mountains beyond.

117 *Mountain Landscape* by Alexander Cozens. Watercolour. (Williamson Art Gallery and Museum, Metropolitan Borough of Wirral)

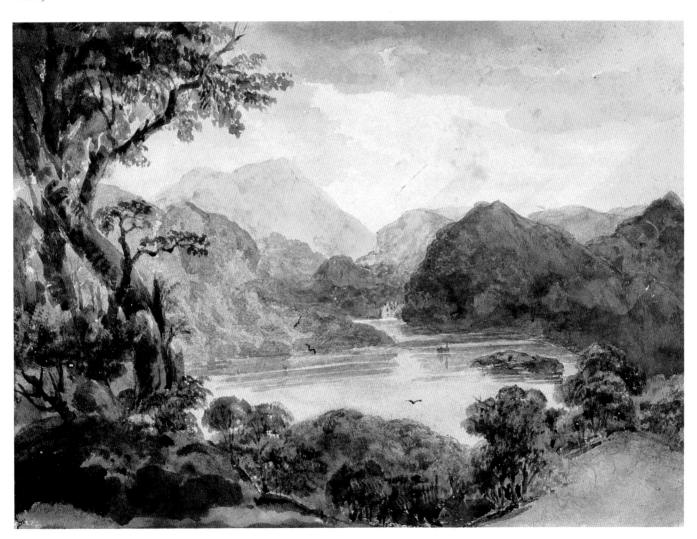

John Varley (1778–1842) is an artist from the transitional period of English watercolours; his work shows influences from the tinted topographical drawings which preceded him, as well as indications of the loose colour work to come. In contrast to the two previous painters, Varley's painting of *Brecknock* (Figure 118) uses much more precisely drawn and clearly defined shapes. Some of the treatment (the trees, for example) derives from etching and drawing techniques. I admire the way this painting is composed, its use of light and its detail.

As with all the paintings in this chapter, observe carefully how certain effects are achieved and relate them to your own work. The sky in this painting is lit with a strong yellow glow from the horizon. The warmth of this colour is carried onto some of the buildings and reflected in the water below. Figures introduced in different parts of the painting help to establish scale and depth, as does the contrast between foreground detail and the silhouetted suggestions of trees and buildings beyond the bridge. The mood is quiet, calm and tranquil.

118 *Brecknock* by John Varley. Watercolour. (Blackburn Museum and Art Gallery)

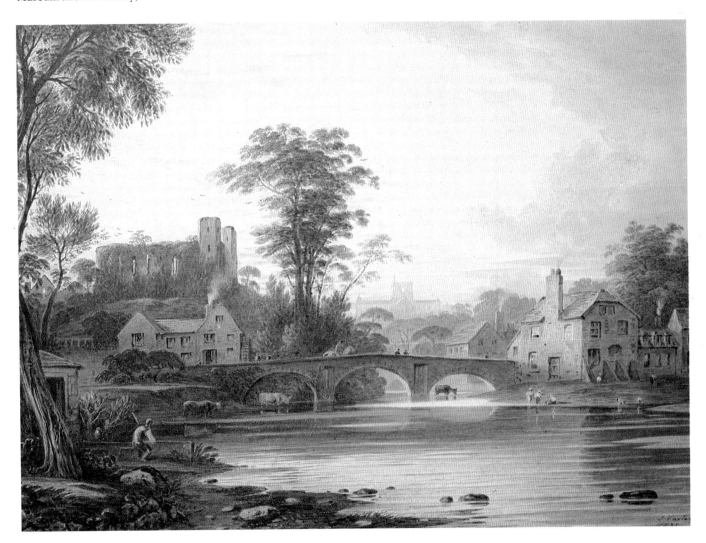

J. M. W. Turner (1775–1851) revolutionized watercolour techniques. Previously, the first stage of a painting had been to use grey or another neutral tint to lay in the gradations of light and shade. Each shape would subsequently be painted over with the appropriate colour. This method resulted in sombre, rather heavy paintings, bearing some similarity to oil painting methods of the same time. Turner's method was to use direct colour, painting immediately the colours he saw and which would best convey the atmosphere and effects he wanted. This proved to be the foundation of modern watercolour methods. Through delicate hatching, he was able to produce wonderful qualities of colour which made the painting glow in his distinctive style.

Like the later Impressionists, Turner's great fascination was for light, particularly skies. In Figure 119 the sky dominates and casts its influence throughout the painting. The whole picture radiates light. Producing some 20,000 watercolours, Turner was a great innovator, experimenting with different wash techniques, wiping out with a rag, scratching through colour with a fine point or the blunt end of the brush, and using body colour. See also Figure 2 (page 8).

119 *Shoreham* by J. M. W. Turner. Watercolour. (Blackburn Museum and Art Gallery)

Paul Sandby (1725–1809) was a topographical artist, painting pictures of country estates and at one stage working on Ordnance Survey maps of Scotland. His early studies in drawing, etching and aquatint influenced the techniques he used in his landscape watercolours. In many respects, his watercolours are more tinted drawings than freely conceived paintings.

His highly resolved works were usually painted in transparent washes, sometimes incorporating both wash and opaque techniques. Although his emphasis is on drawing and design, his paintings are not without feeling or a sense of atmosphere. Like many artists of the period, he was fond of using figures to give a reference of scale, consequently emphasizing the vastness of Nature. He has been described as 'the father of watercolour painting' and 'the only man of genius who paints real views of Nature' because he painted the landscape as he saw it rather than rearranging it to make something more picturesque.

120 *Landscape with Castle and Stream* by Paul Sandby. Watercolour. (Williamson Art Gallery and Museum, Metropolitan Borough of Wirral)

Richard Parkes Bonnington (1801–28), although born
in England, spent most of his short life working in
France. His landscapes are rich in colour and full of
vitality. They have a poetry, freshness and use of
high-key colour which is reminiscent of Constable. His
favourite subjects were marine and coastal scenes, and
flat, open landscapes which use a low horizon and a
large sky area. In Figure 121, notice the power of the
sky, despite the simplicity and economy of colour and
brushwork. His paintings have a feeling for
spontaneity, light and colour which heralds the path
towards Impressionism. Look at the marvellous
shadows in this painting and the way they are used to
unify the composition.

121 *Landscape* by Richard Parkes Bonnington. Watercolour.
(Williamson Art Gallery and Museum, Metropolitan Borough of
Wirral)

Peter de Wint (1784–1849) loved to paint direct from the landscape, especially in the flat country around Lincoln which lent itself to his favourite themes of open stretches of river scenery under a calm, luminous sky. His style is noted for the simplicity and breadth of light and shade, and the use of clear, fresh colour. In technique he was a purist, objecting to any use of Chinese white or body colour and painting in very liquid, sometimes almost wet-in-wet, washes. Study the broad treatment of his *Sussex Landscape* (Figure 122) and compare this to *A Lincolnshire Landscape* (page 53).

122 *Sussex Landscape* by Peter de Wint. Watercolour. (Blackburn Museum and Art Gallery)

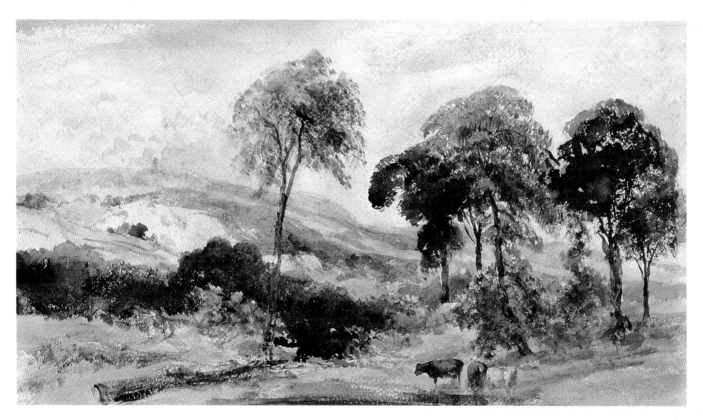

Samuel Palmer (1805–81) is known as a visionary
pastoral landscape painter, whose most impressive
and influential work was inspired by the Shoreham
Valley in Kent in the late 1820s. Set at dusk or by
moonlight, such landscapes have a sense of mystical
silence. With their dramatic lighting effects, often using
a shaft of bright light, they look as though they were
illuminated from Heaven itself. Sometimes he used
ink and wash with a good deal of intricate drawing;
in other works he combined colour washes with
gouache, as in Figure 4 (page 9).

However, many of his landscapes are extremely
competent, straightforward watercolours, as in Figure
123. What detail, what mastery of light and shade, and
what majesty in the giant oak tree!

123 *Returning to the Farm* by Samuel Palmer. Watercolour.
(Blackburn Museum and Art Gallery)

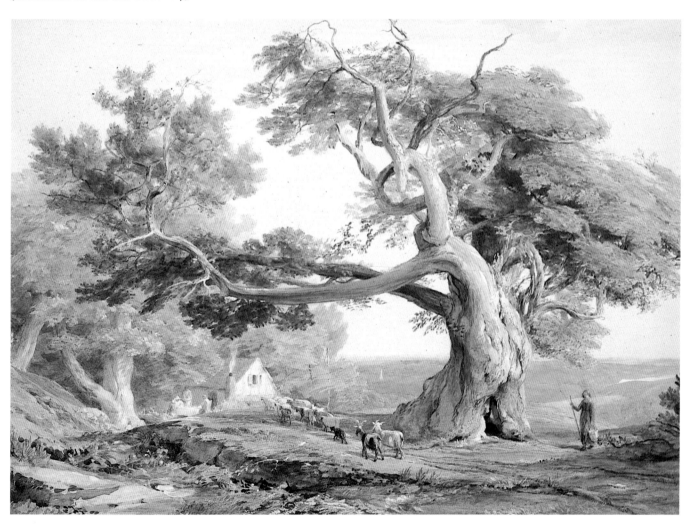

Framing and Displaying Your Work

● Choosing mounts ● Framing ●

8

Framing and Displaying Your Work

IT IS WELL WORTH the trouble of mounting, framing and displaying a painting which is particularly successful. Hang it in your own home or submit it for display in a local open exhibition, which will also give you the opportunity to meet other artists and discuss their work. Remember that painting is a form of communication, so don't keep all your ideas to yourself!

Watercolours should be framed under glass, usually with a fairly wide, unpretentious mount. There has to be some sympathy between mount and frame and, of course, the purpose of both is to enhance your painting by providing a space around it which helps to concentrate attention on the work itself.

CHOOSING MOUNTS

Most landscapes look best with a natural surround – grey, sepia, off-white, cream or pale peach. If the painting involves positive colour or general high-key

124 (Bottom left)

125 (Below)

126 (Bottom right)

127

128

colour, then the mount can be a little more adventurous in colour, but it must not be more striking than the painting. If you have the opportunity, try out several colours round the edges of your painting just to test how they look. Use a simple window mount (Figure 124), a double mount (Figure 125) or a grooved or line-enhanced mount (Figure 126). You can use a mount with margins of equal width all the way round, but it is generally visually more pleasing to use one with a wider margin at the bottom.

You can cut your own mounts with a sharp craft knife or a special mount-cutter, using mounting card purchased from your local art shop. However, it is not as easy as it sounds or looks and my advice is to have mounts made for you at a framing shop; they need not be expensive. A poorly cut mount or a badly made frame will do nothing but detract from your painting.

Measure carefully the size of the mount you require. If your painting is not wholly successful, you can crop or reduce its size, concentrating on the good bit! Fix the painting to the back of the mount by applying masking tape round the edges (Figure 127).

FRAMING

Choosing a frame can be difficult: the wrong frame will do a lot of harm to the painting. Again, I advise nothing too ostentatious. Keep it simple and relate it to the mount. A good way of choosing a frame is to take the painting to a picture framer and try out a variety of wood samples to see which looks best. My preference is for a simple natural wooden frame (Figure 128 (a)) or a stained wood with a thin contrasting edge (Figure 128 (b)), but select frames which you think best suit your work.

Other alternatives are to buy old frames from junk shops and market stalls, strip them down and re-varnish or re-spray them, or to order frames by mail order (see page 109/110). Of course, if you have the skill and equipment you can make them yourself!

Glossary

Check the Contents and Index for other references to terms and techniques.

Aerial perspective The effect of the atmosphere on the distant landscape such that tonal contrasts become muted and colours weaker and cooler. Thus, distant mountains may seem bluish.

Alla prima painting *see* Direct painting

Bleed The blurring of the edges of the area of colour, sometimes caused by the type of paper, but more usually by painting wet-in-wet.

Blending The working together of adjacent colours so as to effect a smooth, gradual transition from one colour to another.

Body colour Using opaque watercolour paint (gouache) or mixing a coloured pigment with white.

Buckling The distorted surface of paper which has been wetted.

Chiaroscuro Dramatic contrasts of light and dark in a painting, as for example in the work of Leonardo da Vinci.

Chroma The richness or intensity of a colour.

Cockling *see* Buckling

Complementary colour Opposite colour on the colour wheel (see page 21). The complementary of any primary colour is a mixture of the remaining two, thus red and green are complementary colours. Such colours are said to balance and harmonize.

Contre-jour painting Using low-key colour with high-key accents or details.

Cool colour A colour in the range of blue, blue-green and blue-violet.

Deckle The irregular edge of a sheet of handmade paper.

Direct painting Avoiding underpainting and preliminary washes so that colours and techniques are applied in one go, without further modification, and the painting completed in a single session.

En plein air Painting directly from Nature so as to capture the immediate effects of light and atmosphere.

Feather-out Using a fan brush or similar soft-haired brush to lightly blend and diffuse colours, and reduce obvious lines and edges.

Fixative A type of thin varnish which is sprayed over soft pencil, pastel and charcoal techniques to prevent them smudging and offsetting.

Focal point The part of the painting that attracts most attention. Usually the composition is so devised that shapes and lines lead you to a particular object of interest.

Gouache Opaque watercolour which consists of pure pigment in a gum binder with a white pigment added. In contrast to pure watercolour, it does not dry in a transparent way, with the underlying support influencing the colour. Rather, it dries as solid, flat colour which can be used to add details, or to strengthen or contrast certain areas in an otherwise transparent watercolour painting.

Impasto Using very thick paint.

Intensity Strength of colour.

High key Using bright, rich and warm colours and light tones.

Highlight The lightest area in a painting. In a watercolour, this is often a small patch of the white, unpainted support, used to suggest the area which attracts or reflects the greatest amount of light.

Hot-pressed A type of paper which in its manufacture is rolled or pressed between hot metal plates. Characteristically, it has a smooth, sometimes slightly glazed surface.

Hue The actual colour (e.g. red) as opposed to the tone or strength of colour.

Laid A type of paper characterized by vertical and horizontal lines in its structure, caused by the way the pulp has been pressed against a wire frame in its manufacture.

Laying in Applying preliminary washes of colour to organize the basic composition of a painting.

Local colour The actual colour of the subject, rather than the colour as influenced by different lighting conditions.

Low key The use of dull, dark or sombre colours.

Masking fluid A rubber compound solution brushed onto areas to prevent them from accepting paint. When the painting is finished, the masking fluid can be rubbed off or peeled away.

Medium Any drawing or painting material, e.g. charcoal, watercolour, gouache.

Mixed media Combining two or more media to make a painting, e.g. ink and watercolour.

Monochrome Confining the work to tones of a single colour.

Not Short for 'not hot-pressed', and thus a type of paper with a relatively coarse or open-surface texture.

Opaque The use of solid areas of colour, with the lighter tones made by adding white rather than diluting the pigment.

Optical mixing The overall effect of a single colour, achieved by using a mixture of small dabs of two or more colours across a particular area of the painting.

Palette A mixing surface and, more importantly, the range of colours used to complete a painting.

Pigment Paint.

Primary colour A basic colour which cannot be mixed from any other source, i.e. red, yellow, blue.

Rough Heavy-quality artists' paper.

Secondary colour Made by mixing two primary colours, i.e. green, orange, violet.

Stretching Process of wetting and taping down paper to a board so that when it is subsequently wetted it always dries flat (see page 87).

Support The surface on which to paint, mostly different types of paper.

Tidemark Patchy marks left around the edges of a wash of paint which has dried unevenly.

Tint Greatly reduced colour, made by diluting it with a lot of water, or a light tone made by mixing pigment with white.

Tone The light or dark value of a colour.

Tooth The coarseness or texture of the surface of paper.

Transparency The quality of colour, such as watercolour, which transmits rather than reflects light, so that the whiteness of the paper may show through and influence the colour and painting effects.

Underpainting The first stages of a painting, maybe colour washes, over which subsequent colours and effects are worked.

Value The strength of colour in terms of light or dark; how much it may reflect or transmit light.

Warm colour A colour in the range of red, purple, orange or orange-yellow.

Wet-in-wet Working wet colour into or over a wet layer already on the paper.

Wet-over-dry Working wet colour over washes of paint which have been allowed to dry.

Wove Paper that is made against a closely woven wire mesh so that no obvious surface texturing or internal pattern structure is noticeable.

Useful Addresses

GREAT BRITAIN

Most basic materials are obtainable from your local art shop, although they may not stock an extensive range of good-quality watercolour paper. Some of the suppliers listed below do mail order and the others provide catalogues so that you can order through your local retailer.

General art materials

Fred Aldous, The Handicrafts Centre, 37 Lever Street, Manchester M60 1UX

Art and Crafts, 10 Byram Street, Huddersfield HD1 1DA

Art-Mail, 11–15 Clarendon Place, St George's Cross, Glasgow G20 7PZ

Atlantis Art Warehouse, Margaret Street, Birmingham B3 3BX

L. Cornelissen, 105 Great Russell Street, London WC1

Crafts Unlimited, 178 Kensington High Street, London W8 (and branches)

Daler-Rowney and Co. Ltd, P.O. Box 10, Bracknell, Berkshire RG12 4ST

Reeves and Sons Ltd, Lincoln Road, Enfield, Middlesex

Winsor and Newton Ltd, Whitefriars Avenue, Harrow, Middlesex HA3 5RH

Watercolour papers

R. K. Burt & Co. Ltd, 57 Union Street, London SE1 (handmade papers, including Fabriano and cold-pressed papers for wet techniques)

Conté (UK) Ltd, Park Farm Road, Folkestone, Kent CT19 5EY (Canson/Cotman papers for wet techniques)

Daler-Rowney and Co. Ltd, P.O. Box 10, Bracknell, Berkshire RG12 4ST (Saunders Waterford papers and others)

Falkiner Fine Papers Ltd, 76 Southampton Road, London WC1B 4AR (range of hand-moulded and machine-made papers, including Arches, Fabriano and Saunders)

Khadi Papers, 11 Tregarth Road, Chichester, Sussex PO19 4QU (various handmade cotton and fibre papers)

T. N. Lawrence, 119 Clerkenwell Road, London EC1R 5BY (various papers including Barcham Green)

Two Rivers Paper Company, Pitt Mill, Roadwater, Watchet, Somerset TA23 0QS (175 lb cotton rag papers, including tints)

Framing

Albany Framing, 4 Broomsfield, Sunbury-on-Thames, Middlesex TW16 6SW

Artists' Home Supplies, Units 40/41, Temple Farm Estate, Sutton Road, Southend-on-Sea, Essex SS2 5RZ

Artists' Paraphernalia, 30 Moor Street, Chepstow, Gwent

Charisma, 57–59 Station Road, Harrow, Middlesex HA1 2TY

Chatfields, Ashlea Studio, 41 Ecton Lane, Sywell, Northamptonshire NN6 0BA

Robert Pearce, 65 Alexandra Street, Burton Latimer, Northamptonshire

Polyframes 87, Unit 2, Valelands Nursery, Marle Green, Horam, East Sussex TN21 9HB

Demonstration videos

APV Films, 6 Alexandra Square, Chipping Norton, Oxon OX7 5HL

Seeba Films, 9 St John's Street, Lechlade, Gloucestershire GL7 3AT

Book clubs

Artists' Book Club Ltd, P.O. Box 178, Oxford OX2 8RP

Artists' Choice Ltd, P.O. Box 3, Huntingdon, Cambridgeshire PE18 0QX

Arts Guild, Book Club Associates, 87 Newman Street, London W1P 4EN

Magazines

The following magazines carry informative articles on techniques, details of exhibitions, competitions and courses, as well as trade advertisements for specialist equipment and mail order items:

The Artist, 63–65 High Street, Tenterden, Kent TN30 6BD
The Artist's and Illustrator's Magazine, 4 Brandon Road, London N7 9TP
Arts Review, 69 Faroe Road, London W14 0EL
Leisure Painter, 63–65 High Street, Tenterden, Kent TN30 6BD

Art clubs and societies

Many towns have an art club or society which meets on a regular basis for working sessions, demonstrations and perhaps excursions, and usually holds an annual exhibition. Details should be available in your local library.

Classes and courses

The National Institute of Adult Education, 35 Queen Anne Street, London W1, will provide a list of residential short courses covering a wide range of art and crafts. Contact your local Education Authority to find out which schools and colleges run evening classes in your area.

There are many summer schools and weekend courses run by practising artists, and also organized holidays to paint in other parts of the world. These are advertised in magazines such as *Leisure Painter* and *The Artist*, or write to Artscope, Units 40/41 Temple Farm Estate, Sutton Road, Southend-on-Sea, Essex SS2 5RZ.

My advice is to find a tutor who will help develop your work as an individual, rather than those who preach and commercialize a single technique.

Exhibiting your work

Whether you belong to an art club or not, there are normally other local exhibitions in which you can take part. More prestigious national exhibitions and competitions are advertised in art magazines.

Work for exhibition must be mounted and framed under glass, and may need to conform to certain restrictions regarding subject matter, size and technique.

Where to see watercolours

There are extensive collections of watercolours in many provincial art galleries, as well as those in London at the British Museum, the Victoria and Albert Museum and the Tate Gallery (including the Turner Collection). In my research, I have been impressed by the many fine landscape watercolours in art galleries throughout the country, some of which illustrate this book. I recommend *The Art Galleries of Britain and Ireland: a guide to their collections* by Joan

Abse, Robson Books Ltd, to help locate galleries and the range of their collections.

Visit your local museum or art gallery and ask the Curator if there are other paintings which are not displayed.

U.S.A.

If possible, visit a good retail store for help and advice and the opportunity to test materials, especially paper, before purchasing. The following suppliers will supply materials by mail order, otherwise via a retail outlet:

General art materials

Alvin and Co. Inc., 1335 Blue Hills Avenue, Bloomfield CT06002
Binney and Smith Inc., 1100 Church Lane, Easton PA18044
Chartpak, One River Road, Leeds MA 01053
Dick Blick Company, Suite 150, P.O. Box 1267, Galesbury IL 61401
The Fax Company, 62 East Randolph Street, Chicago IL 60601
New York Central Art Supply Inc., 62 Third Avenue, New York NY 10003
Palette Shop Inc., 342N Water Street, Milwaukee WI 53202
Peal Paint Co., 308 Canal Street, New York NY 10013
St Louis Crafts Ltd, 44 Kirkham Industrial Court, St Louis MO 63119

Watercolour papers

Andrew/Nelson/Whitehead Paper Corporation, 3–10 48th Avenue, Long Island City NY 1101
Rupaca Paper Corporation, 110 Newfield Avenue, Edison NJ 08818
Strathmore Paper Company, South Broad Street, Westfield MA 01085

Studio equipment

Artist & Display Supply Inc., 9015 West Burleigh Street, Milwaukee WI 53222
Sam Flax Art Supply Co., 39 West 19th Street, New York NY 10011

Framing

Presto Picture Frames, 1237 Shipp Street, Hendersonville NC 28739

Magazines

Artists' Magazine, F. & W. Publications Inc., 1507 Dana Avenue, Cincinnatti OH 45206

Draw Magazine, Calligrafree, 43 Anaka Avenue, Box 98, Brookville OH 45309

Illustration, Art Instruction Schools, 500 South Forth Street, Minneapolis MN 55415

Classes, courses and art societies

For an extensive list of art museums, schools and associations in the U.S.A. and Canada, consult the *American Art Directory*, published by R. R. Bowker Co., 245 West 17th Street, New York NY 10011. Educational and instructional opportunities – schools, colleges, workshops and private teachers – are listed in *The American Artist and Art School*

Directory, published by Billboard Publications Inc., 1515 Broadway, New York City NY 10036.

Exhibiting your work

Venues and competitions are advertised in art and craft magazines, especially in *Art and Craft Catalyst*, Box 433, South Whitley IN 46787.

Where to see watercolours

There are many city, state and university art galleries where watercolours are on permanent view or can be seen on application to the Director. *The Official Museum Directory*, published by Macmillan Directory Division, Third Avenue, New York, NY 1022, lists all the art museums and galleries in the U.S.A.

Further Reading

Wilfred Ball, *Weather in Watercolour*, Batsford, 1986

Wilfred Ball, *Wet Watercolour*, Batsford, 1987

Ann Blockley, *Learn to Paint/Countryside in Watercolour*, Collins, 1988

Robert Canning, *Picture Framing*, Ward Lock, 1986

Kenneth Clark, *Landscape into Art*, John Murray, 1979

John Cooke, *Waterscape Painting*, Batsford, 1987

John Croney, *Drawing by Sea and River*, Batsford, 1985

James Fletcher-Watson, *The Magic of Watercolour*, Batsford, 1988

Hazel Harrison, *The Encyclopedia of Watercolour Techniques*, Headline Book Publishers, 1990

Ettore Maiotti, *The Watercolour Handbook*, Aurum Press, 1990

Judy Martin, *Drawing with Colour*, Cassell, 1990

Ralph Mayer, *The Artist's Handbook of Materials and Techniques*, Faber and Faber, 1987

Ron Ranson (ed.), *Watercolour Impressionists*, David and Charles, 1989

Graham Reynolds, *A Concise History of Watercolours*, Thames and Hudson, 1985

Ian Simpson, *The Challenge of Landscape Painting*, Collins, 1980

Ray Smith, *The Artist's Handbook*, Guild Publishing, 1987

Michael Spender, *The Glory of Watercolour*, David and Charles, 1988

Jonathan Stephenson, *The Materials and Techniques of Painting*, Thames and Hudson, 1989

Michael Wilcox, *Colour Mixing System for Watercolour*, Batsford, 1984

Michael Wilcox, *Colour Theory for Watercolour*, Batsford, 1984

Index